A Waterloo County Album

glimpses of the way we were

A *Waterloo County* Album

Stephanie Kirkwood Walker

A HOUNSLOW BOOK
A MEMBER OF THE DUNDURN GROUP
TORONTO · OXFORD

Publisher: Anthony Hawke
Copy-Editor: Andrea Pruss
Design: Jennifer Scott
Printer: University of Toronto Press

National Library of Canada Cataloguing in Publication Data

Walker, Stephanie Kirkwood
 A Waterloo County album : glimpses of the way we were / Stephanie Kirkwood Walker.

Includes bibliographical references and index.
ISBN 1-55002-411-6

1. Waterloo (Ont. : County)—History—Pictorial works. I. Title.

FC3095.W38W34 2002 971.3'44 C2002-902286-X F1059.W32W34 2002

1 2 3 4 5 06 05 04 03 02

THE CANADA COUNCIL | LE CONSEIL DES ARTS
FOR THE ARTS | DU CANADA
SINCE 1957 | DEPUIS 1957

Canada

ONTARIO ARTS COUNCIL
CONSEIL DES ARTS DE L'ONTARIO

We acknowledge the support of the **Canada Council for the Arts** and the **Ontario Arts Council** for our publishing program. We also acknowledge the financial support of the **Government of Canada** through the **Book Publishing Industry Development Program** and **The Association for the Export of Canadian Books**, and the **Government of Ontario** through the **Ontario Book Publishers Tax Credit** program.

J. Kirk Howard, President

Printed and bound in Canada.
Printed on recycled paper.

www.dundurn.com

Dundurn Press
8 Market Street
Suite 200
Toronto, Ontario, Canada
M5E 1M6

Dundurn Press
73 Lime Walk
Headington, Oxford,
England
OX3 7AD

Dundurn Press
2250 Military Road
Tonawanda NY
U.S.A. 14150

For
Jim,
still surprised to be in Waterloo County,
&
Patricia,
who remembers when she was.

Table of Contents

Opening Thoughts

On a warm day in early June 1946, a man named Chandler arrived at our house in Blair to take photographs marking my grandfather's retirement. In 1894, Matthew Wilkinson Kirkwood had come to Preston from Peel County to follow his dream of working for the railway. Now, at seventy, having stayed on through the war years, he was retiring as general manager of the Grand River Railway and the Lake Erie and Northern Railway. The photo feature, which duly appeared in the *Globe and Mail*, was entitled "Railway Veteran Retires after 52 years to Vest-Pocket Paradise."

Mr. Chandler's visit had created unaccustomed activity that day in Paradise as he herded the family from one promising location to the next. After this particular photograph was taken, the three of us in it were coached for a repeat. "This time," he said to me, "remember to look at the geese, not at

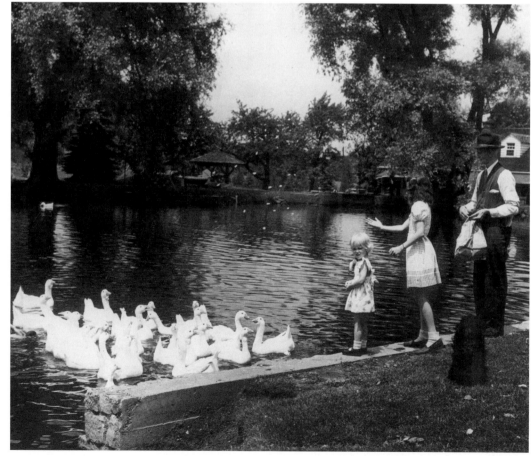

the camera, and don't get too close to the edge." But that second shot didn't work nearly so well. In this one, my backward glance, which I like to think shows an early regard for the mystery of photography, breaks through the picture surface with innocent queries. *Just what is going on here? Who is this man with the camera and why am I wearing my good shoes to feed the geese?*

This tableau neatly gathers together elements of my interest in old photographs of Waterloo County and in a book more visual than verbal. There is more going on here than the moment we glimpse; the photograph contains hints of early German settlement, which remain mute without description. These geese float on a pond created to supply energy to a building, which was our home. Built around 1825, with thick stone walls and set into a hillside, the structure served multiple functions through the nineteenth century, as need and opportunity demanded. A tannery to begin with, it had also been a distillery, a fish hatchery, and, as the nineteenth century turned into the twentieth, a source of electricity for the street lights in nearby Preston. The *Galt Daily Reporter*, using some of the same photographs, noted the history of the site and the fact that, in the twenty years since he had purchased the property, my grandfather had transformed it "into a virtual fairyland of beauty and a miniature game preserve." Change. Before this so-called fairyland there was a plain, functional, early settlement building; before the dam there was bush, a small creek, and a swamp. Constant change moves over the surfaces of the county, unpredictably but apparently inevitably — that is really at the heart of what is going on.

Photographs need contexts: they bear an elusive relation to story. If the image is familiar, stories can tumble into imagination, pulling memory along. If there are threads that can be drawn into historical narrative, success will depend on a working knowledge of the past. My sister, whose breadcrumbs are neatly cast into the centre of the photograph, inherited our grandfather's interest in family and local history, and his papers. Fed by her spirit of inquiry, a cache of photographs, and the rich historical awareness that distinguishes residents of Waterloo County, my delight in the narrative density of images is unending. The pond in this photograph, its surface alive under metaphorical shadows from other times, is a home base for my imagination and a centre of what might be termed my primary landscape.

Sensitivity to a local past, which many share, fosters legend. When I was eight or nine years old, my fair weather shortcut from home to the two-room school in Blair followed a path that began with a long climb, edged along the cemetery fence, and then dropped steeply down to the schoolyard. When our teacher read Mabel Dunham's *Trail of the Conestoga* (a novel that depicts the first Mennonite settlers' arrival in Waterloo County) to the class, the details were easily absorbed by our imaginations. High on that cemetery hill, under a tall tree, sat the grave marker of John Bricker; his death in the novel, when he was just our age, tuned each listening child's ears to a past that lay very close to the village that belonged to us.

From the top of that hill, which is wooded now but was bare then, we had a stunning panoramic view of the Grand River. We could see the river bend along the edge of the wide flood plain, join the Speed River at Preston, and then move away toward Galt with its three bridges. John Moss, a Canadian novelist and critic who spent part of his childhood in a house on that very hill, has described his own sense of this vibrant past: "I grew up in borrowed territory. My forebears settled the Grand River Valley, Mennonites and Mohawks pool in my genes, and layer upon layer of newcomers were immersed in their generous confluence, until in my childhood we thought ourselves historically inevitable, being in Waterloo County on the very cusp of time."[i]

Every corner of the five townships in Waterloo County will have comparable sensibilities and powerful landscapes to sustain them. Figures from other eras move easily across a county that has noticed the work of their hands. Historical associations; local history collections and archives; heritage museums and properties; university programs generating theses; books, journals, and newspapers; stories and festivals — all of them chronicle change with footnotes to the past and contribute to a palpable sense of where "here" is.

When I set about finding photographs for this book — pictures of the county, images to represent where cameras had been — habits associated with photography surprised me once again. Some photographs have become heritage images, through widespread familiarity and a shared sense of their significance. A photograph of "the Kaiser's bust" being retrieved from the lake in

Berlin's Victoria Park in 1914 heads this list with hints of the passions stirred by the First World War. In another photograph with an indelible pedigree, one that brings an easy smile, water tossed from a parapet at Waterloo College freezes just before it splashes onto the heads of unsuspecting students standing below. Then there are photographs that, like rare blossoms, have surfaced for particular publications only to disappear again into private collections. Photographs in public collections, on the other hand, are becoming more accessible with digitization; online photographs in the National Archives of Canada or in the Toronto Public Library's extensive collection are examples of this.

The general archive, an aggregate of the photographs available on or in Waterloo County, can best be described as a dispersed, fascinating, and unpredictable source of insight. Among the images that are readily available, some places or activities are more frequently represented than others, some types of photographs survived while others faded, sensibilities shifted from one style of representa-

tion to another. Much has been written about the spurious reality of photographs, their capacity to frame and isolate portions of a seamless world, to beautify any human condition, however disturbing. In the twenty-first century, we can navigate these shoals with hard-won skills, for the most part. We have learned to balance the growth in our capacity to see against the deficits of false assumptions. We can also discern, fairly quickly, which images are worth a lingering gaze. Otherwise we would have been undone simply by the proliferation of representations.

Although this is not a book about photographic technologies, remembering how varied and changeable they are is never amiss. To emphasize the point, I offer this fading artifact. My grandfather, second from the left with the braces, carefully wrote "August 8-49" in pencil on the back. It is the second Polaroid image any of us saw. The first is held jointly by my mother and her friend; that it was source of wonderment can still be patched together from clues remaining on the photograph's mottled surface.

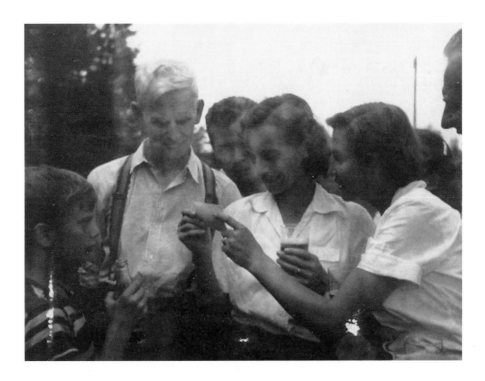

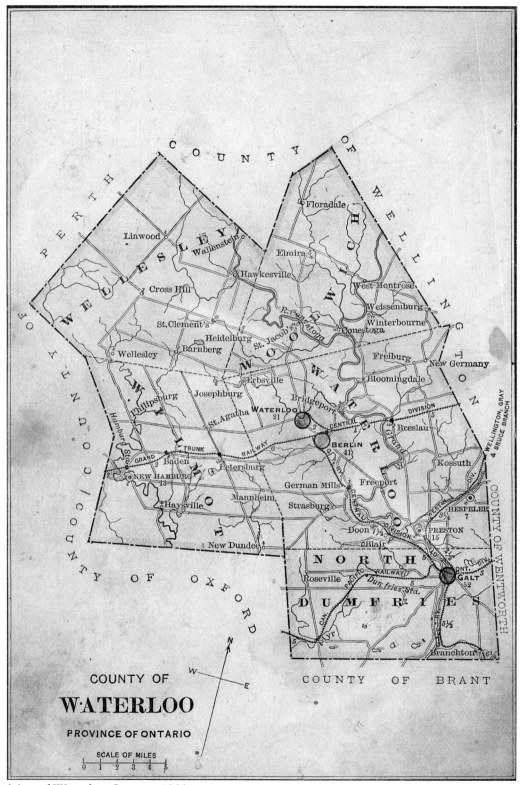

Map of Waterloo County, 1883.[ii]

Region of Waterloo, Doon Heritage Crossroads.

Perpetual Change

The first non-native settlers in what would later become Waterloo County were German-speaking Mennonites from Pennsylvania. They came north seeking land to farm where they could live in peace. In 1800, the first of these pioneering families settled on the banks of the Grand River near Blair and prepared the way for others like themselves to follow. Further south along the river and several years later, in 1816, a Scot named William Dickson acquired a large tract of land. His vision was of a planned community to be settled by immigrant Scots; the town site and centre of his community, an early and felicitous choice, would become the city of Galt. The impact of these two early groups, the Pennsylvania Germans and the Scots, is palpable across the region — although soon enough, and increasingly, others began to arrive from Europe and beyond, contributing to the ethnic diversity that characterizes the Regional Municipality of Waterloo today.

Before the farming settlers arrived, others had stayed in or moved through the Grand River watershed. The Iroquois Six Nations, having supported the British during the American Revolution, sought land north of the Great Lakes when hostilities ended. In 1784, they were granted, in perpetuity, a tract of land six miles wide on either side of the Grand River and along its entire length. The land sales of the early 1800s began only after the Six Nations, under their leader, Joseph Brant, convinced the British to allow the treaty lands to be broken into large blocks. Before the Six Nations, the Mississauga were in the Grand River valley, before them were French explorers, traders, and missionaries, and earlier still was the Neutral nation. Set against this rhythmic movement of peoples, the advent of permanent communities has been recent, and the era of the photograph more recent still.

Indeed, towns were well established before there were cameras to monitor their presence. Yet from the 1850s, when cameras became available, to the 1960s, when technologies, population shifts, and mass culture marked the start of a vastly different, smaller, connected world, cameras in Waterloo County recorded a rich, diversified, and changing way of life. The black and white photographs gathered here from public and private collections portray a county whose legislated life is neatly coincidental with that century: the County of Waterloo came into being in 1852 and passed into history with the advent of regional municipal government in 1973.

My approach in the chapters ahead has been to imagine how we might see the past that lies around us in response to the photo-

graphs that are available at present. I start with the camera itself and a sampling of the photographers who made early use of it. How the camera's lens settled on the natural landscape — the shapes of our hills and the bends in our rivers — and how photographers chose their subjects from the cultural landscape — the one we shape with our habits and buildings — have a considerable effect on how we see and understand this place.

After the initial chapters, the photographs are arranged in thematic clusters that draw experiences together from around the county. Some themes favour certain townships or cities over others: that may be the result of the collecting habits of individuals and institutions, or the condition of photographic materials, or, indeed, the way things were.

1
Remembering the Pioneers

For the first half-century following the arrival of the early Mennonite settlers from Pennsylvania, there were no cameras to distill reality for media-saturated twenty-first-century imaginations. The perception of events that photographs stimulate so easily now, a vigorous sense of a particular time and place detailed in just two dimensions, cannot exist for the pioneering years of settlement. What does exist, with a similar visual objective, are photographs taken much later that show how the story of those early years is kept alive. The sensations of accuracy and objectivity that we associate with photographs come to us by way of artifacts and our own re-enactments. What we can be sure about is that we do remember!

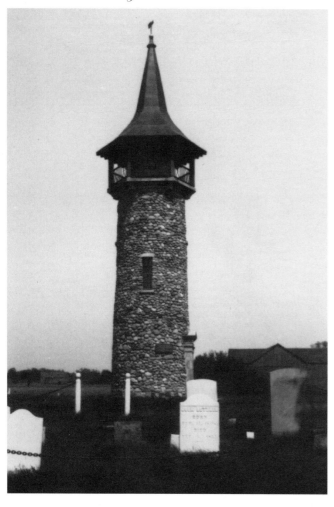

This photograph of the Pioneer Tower, with tombstones from the small cemetery in the foreground, was taken in 1930, just a few years after the tower was built. Even now, though housing developments are crowding in, the sentinel tower can evoke a feeling of isolation and stillness high on the eastern bank of the Grand River, where the first farms were cleared from the bush. Built to commemorate the pioneers, the tower is a testament to the energy later generations have poured into fostering awareness of the county's past.

Pioneer Tower, June 1930.
John Boyd/National Archives of Canada/ PA-089580

The year is 1953, and these four young boys are posing by the grave of John Bricker in the hilltop cemetery in Blair. Many children in the nearby school had heard *The Trail of the Conestoga* read in class and knew the story of the boy's death in 1804, when he was only eight years old. The loss felt by his pioneering family is an emotional turning point in Mabel Dunham's popular account of the early years of Mennonite settlement. Behind the boys, the hill drops away, and Preston lies in the distance across the river valley.

Blair Cemetery, 1953.
Evening Reporter/Waterloo Historical Society

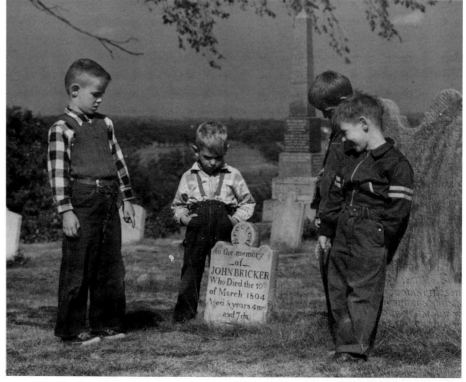

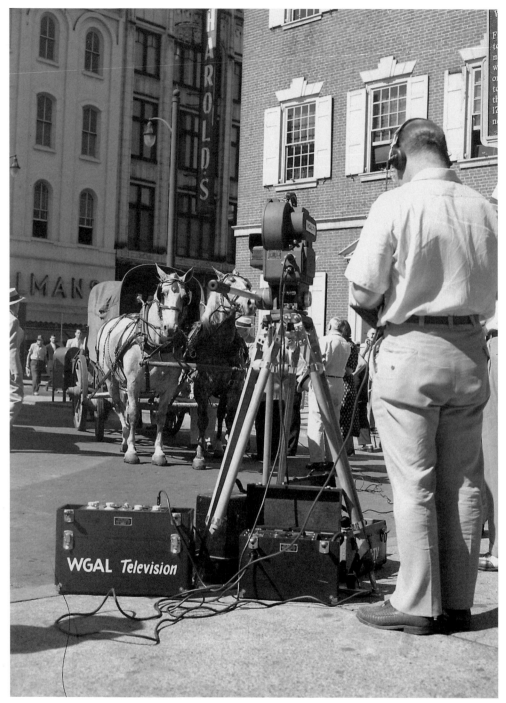

Memory itself is a subject in David L. Hunsberger's photograph of a television crew filming a Conestoga wagon setting out for Waterloo from Lancaster, Pennsylvania. Here the task of remembering, always complex, has substantial physical and technological layers.

This 1952 re-enactment of the original trek marked Waterloo County's first hundred years. Durable and adaptable Conestoga wagons like this one, pulled by sturdy horses, could cross the Allegheny mountains and move through the uncleared bush of Upper Canada, taking to rivers like a boat when necessary. The wagons recall the preparedness and determination of the early farm families and the difficult terrain that separated Pennsylvania from Waterloo by four to six weeks of travel.

Trail of the Conestoga, Lancaster, Pennsylvania, June 1952.
Photo by David L. Hunsberger

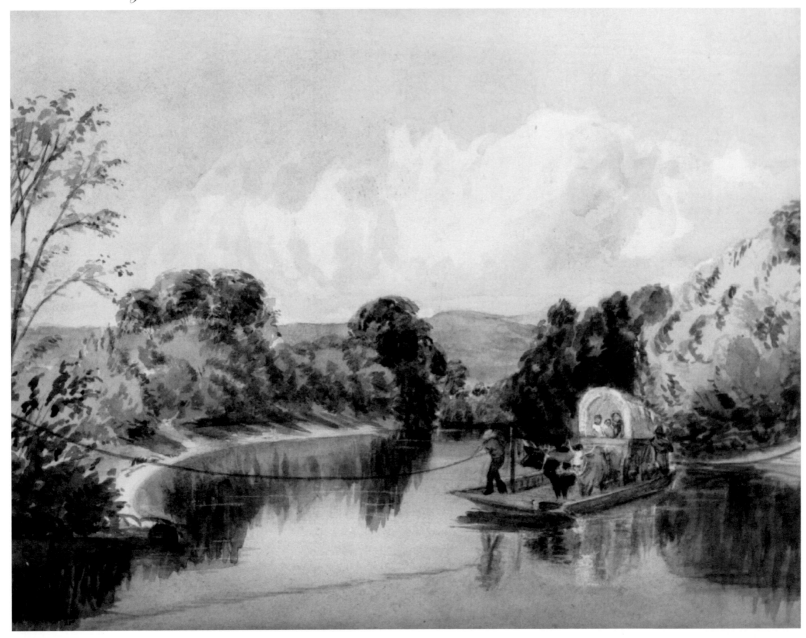

This watercolour of a Conestoga wagon crossing a river by barge is an idyllic, pastoral version of the pioneers' trek. The original, painted in 1875 and now in Ottawa, can be downloaded as a photoprint from the National Archives' website — a teasing reminder that ours is an age of replication. We have intricate, multiple, and convenient techniques for keeping the past beside us.

Conestoga wagon on a barge, crossing a river, circa 1875. G.K./National Archives of Canada/C-036684

2
Waterloo County Photographers

Looking at the contours of the county through the lens of the camera gives a particular view of the past. It is not the intricate, diagrammatic view of the genealogist, whose careful eye watches families join, cluster, and disperse, nor is it the narrative analysis of history, which shapes the past with intention. Instead, photographs play upon our visual sense. We can bring them together in layers, to be pondered one at a time, or we can set them side by side. If versions of Waterloo County are spread out on a library table, how shall they be ordered? By subject, by town, by year? Are images of Victory Loans parades in Galt and Waterloo better savoured side by side or separated and put with their cities? Do we notice whether the camera's lens closed down on small, significant acts or opened to panoramas that mimic maps? Why this, or then, or there exactly? And, a question all too seldom asked, who held the camera?

Frequently, a particular photographer's view of the world will suffuse their work, and so their prints are easily recognized. More often, especially with old photos, the photographer is anonymous. The context may be clear — a familiar place, a remembered occasion. On the other hand, there may be only a hint of context, a cryptic reference written on the back, perhaps just "Dad and Fred."

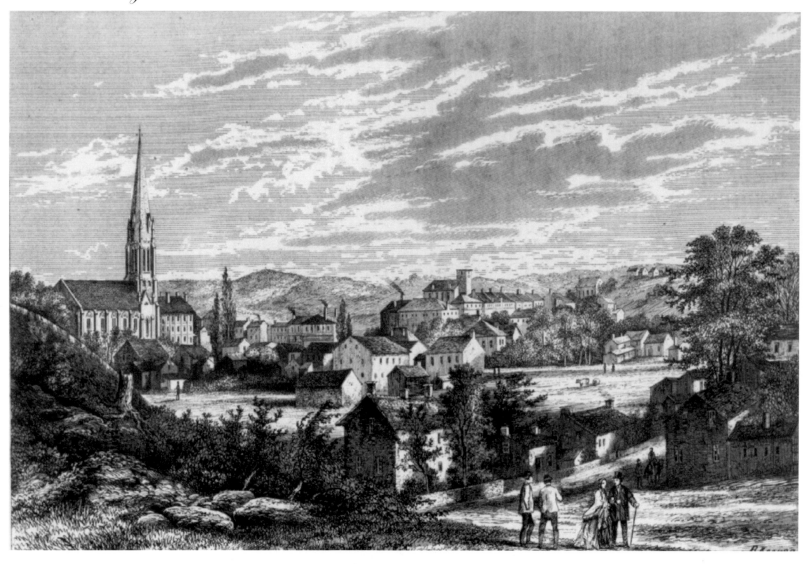

View of Galt, 1872.

From a sketch by A. Farrar. *Canadian Illustrated News*, Vol. VI, November 16, 1872, Page 312. Photo from the National Library of Canada (http://www.imagescanada.ca/)

These two views of Galt, both panoramic, illustrate some of the differences embedded in images. In the earlier version, a sketch published in 1872, the artist depicted the town cradled among hills. Rising steeples soar above other buildings, mirrored faintly by smoke from factory chimneys; together they suggest there is both purpose and progress in late-nineteenth-century Ontario. Individuals gathered on the road in the foreground seem at ease in a benign world.

The other view, a photograph taken by G.R. Berkeley twenty years later, has many of the same characteristics but stimulates a different mood. The domesticity of the figures in the foreground, seated on a hill at the edge of town with their child in a buggy, suggests comparable leisure and prosperity. Faintly visible steeples, factories, and the river identify the same location. In this version, however, the town seems to matter less, in a flattened river valley where the view stretches to a distant horizon and then simply fades. Nonetheless, along with the young couple whose perspective we share, we can marvel at the accuracy of detail in the image and reflect upon the future such a technology promises.

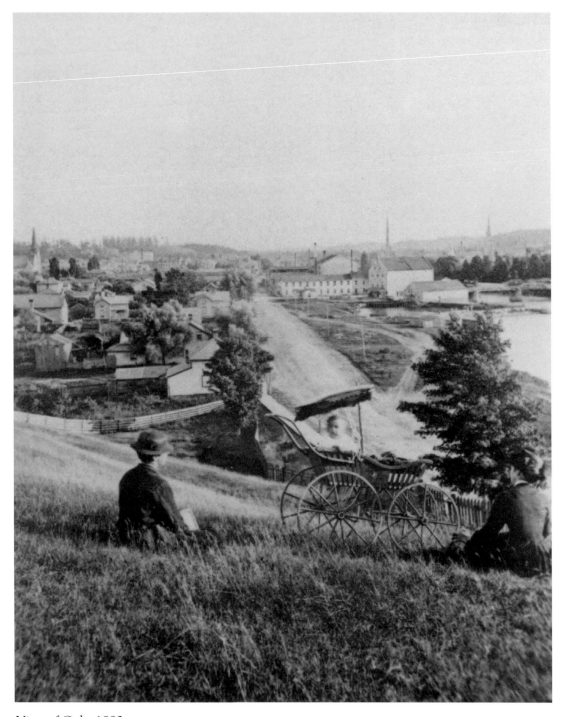

View of Galt, 1892.
G. R. Berkeley/National Archives of Canada/PA-121778

Louis Jacques Mandé Daguerre made his first lasting pictures of Paris streets in the late 1830s, twenty to thirty minutes of exposure time were required, long enough for moving pedestrians to disappear without leaving any trace in the image. As a consequence, the streets appeared deserted, when they were actually bustling with activity. Subtle questions have arisen about image and reality, time and light — but then, as now, invention pushed ahead, and the questions remain. The dilemma prompted one art historian to comment that we too easily forget "a photograph is an *event* transformed into an object. Rather than being a record of *things*, as we often suppose, it is the fixing of light in space over *time*."[iii] So accustomed are we to having photographs for our own purposes of record or pleasure that I suspect we seldom give the matter much thought. Even so, this delicate complexity is worth keeping in mind as a gauge of our own infatuation with the ever-changing medium.

A measure of the speed of developments in photography is that a short fifteen years later, around 1854, George Esson had a daguerreotype gallery in his home in Preston and, soon after, a studio in Galt. In 1884, his son and apprentice, James, whose reputation as a photographer reached far beyond Waterloo County, opened his famed "Atelier" on King Street in Preston. Described as "an elegant and complete establishment" with an abundance of natural light and sophisticated equipment, it drew clients from as far away as Montreal and Ottawa.[iv]

Photography had begun to influence our sense of proportion and space much earlier than either of these views of Galt. When

In this characteristic Esson portrait, a young W.L. Mackenzie King, who would later be prime minister of Canada, has come to the Esson studio from Berlin, as Kitchener was called then, with his parents and his sister Bella.

W. L. Mackenzie King with his parents and sister Bella, circa 1875.
James Esson/National Archives of Canada/C-0007348

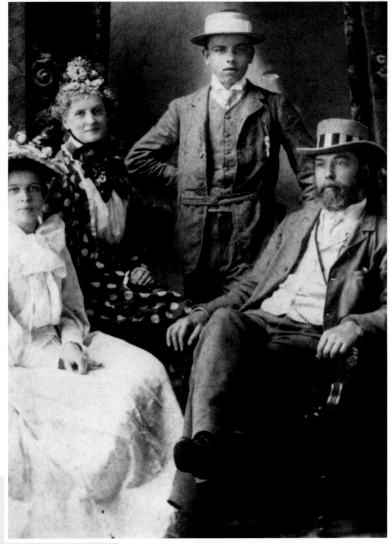

In addition to portraits, James Esson was renowned for his landscape work. His many photographs of Preston captured its atmosphere in the early twentieth century, when the presence of mineral springs made the town a destination for stylish visitors. Esson's image of the dam on the Speed River, taken from the bridge in Preston, just down the road from the main hotels, seems an unlikely subject. However, with the strong diagonal lines of the falls and the railway bridge, the trees reflecting on the still surface of the dam, and the figures posed on the pier, Esson brings together the mix of enjoyment and industry upon which Preston thrived at that time.

The Dam on the Speed River in Preston, 1905.
James Esson/National Archives of Canada/PA-029073

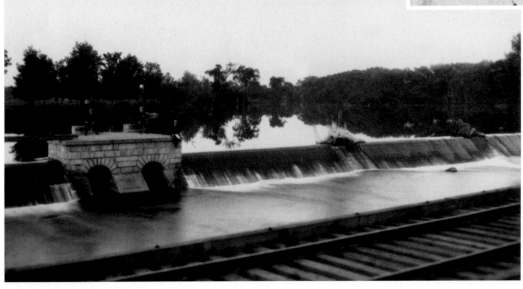

Children heading off to Ki-Y summer camp, Galt, July 1923.
Elliot Law/Law Photography, Galt

The genius of the Essons, father and son, passed on through three more generations to the present. Together, these five photographers have assembled 150 years of events and personalities on film. Elliot Law, the next in line, apprenticed with his uncle, James Esson, and then set up his own studio in Galt in 1920. Forty years later, his son

William took over that studio, and now Peter Ross, his nephew, is the inheritor of both that invaluable archive and an enviable talent.

Elliot Law took this photograph in 1923 in front of the old YMCA building on Queen's Square in Galt. The children, almost into the truck and about to set off for summer camp, have paused momentarily to give him their full attention. According to Doris Huber, who worked in the studio, "Law always carried his camera with him. You very rarely saw him without one."[v]

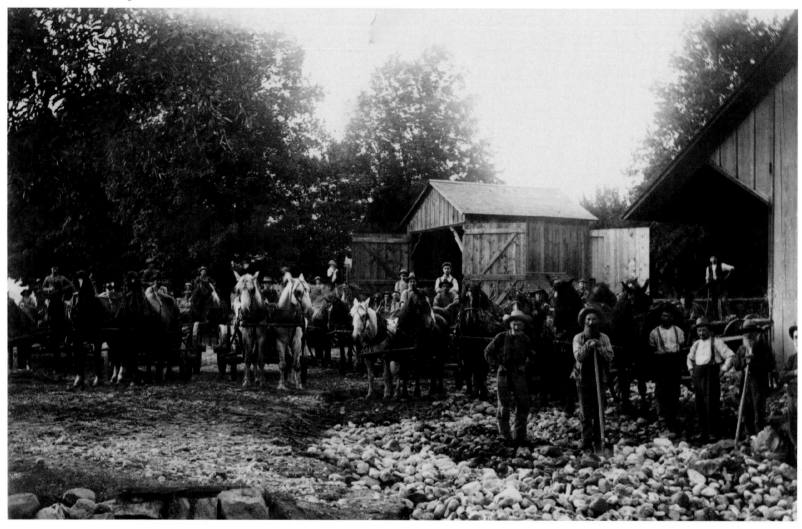

Gathering to repair the damage after the Alder Creek flood, New Dundee, 1912.
Herman Kavelman / Heritage Wilmot

Photographs do not fill gaps as a storyteller might. What we see depends on collectors in the present, certainly, but even more on collectors in the past, perhaps the photographer, a family archivist, or an antiquarian who came upon a cache of photographs and saved them through habit. Thousands of images are boxed or filed in museums and archives, and more sit in attics waiting for attention, ready to be reconfigured according to changing fashions in remembering.

This photograph of the Alder Creek flood of 1912 in New Dundee, by Herman Kavelman, comes from just such a recovered collection of remarkable glass negatives. Kavelman, who died at age ninety-five in 1977, served his village in a number of capacities; aside from his well-known general store, at various times he was fire chief, librarian, and politician. And, evidently, he had a strong interest in photography. When he died, his cameras and glass negatives were auctioned and left to the community. Fortunately, they stayed within a family that knew their value and now, home again, the negatives are being catalogued to take their place in Heritage Wilmot's archives. The quality of glass negatives is confirmed by this image: the rallying neighbours with their equipment, horses, and patience, along with the rocks upon which they stand, are rendered in exquisite detail.

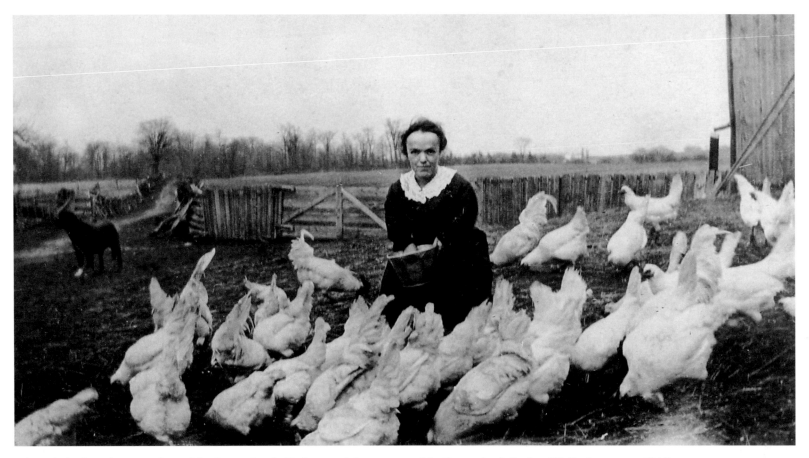

Though little is known about Ida Grenzebach Forler, and there are only a small number of her photographs to weave into the county's past, like Kavelman's, her work is distinctive. She came from Hickson, just west of Waterloo County, to the village of Wellesley to live with an aunt, whose husband, Henry Forler, was a shoemaker. After the aunt died, the very small Ida married the very tall Henry. Ida herself is remembered as a fun-loving woman with a hearty laugh, who was fond of children. The shop where she lived and worked with Henry has been preserved as the tailor's shop at Doon Heritage Crossroads.

Ida worked on both sides of the camera. She likely designed the photograph in which she is surrounded by chickens. In the other example, an image of children in a ring, she is the photographer. Her images — domestic, agricultural, and rural — are characteristically strong in pattern and composition.

Ida Grenzebach Forler, Wellesley, circa 1917.
Region of Waterloo, Doon Heritage Crossroads

Children in a ring, Wellesley, circa 1917.
Ida Grenzebach Forler/Region of Waterloo,
Doon Heritage Crossroads

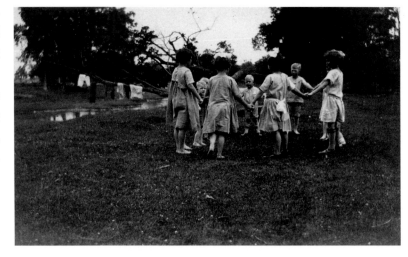

ties are redefined. The pressures of tourism, as prosperity took hold in the decades following the Second World War, created new desires for tangible evidence of the way we once were.

Two men leaning on a fence, date unknown. Local History Department, Waterloo Public Library

Photographs with very little contextual information can be tantalizing simply because mystery surrounds them. Little more is known about these two engaging young men, one posing with a cigar in his mouth and his foot on the fence, than what we see. The image comes from a group of glass negatives, now part of the Waterloo Public Library's collection, that were found within the walls of a farmhouse near Kitchener that was undergoing renovation. Other negatives found at the same time include local landmarks that can be dated around 1900. The faded, peeling photograph of the women seated together with a child in a parlour has been dated around 1895. Nothing more is known — except, of course, that both images are important metaphors for time and change, and each contains enough information on cultural habits to entrap any imagination ready to devise a tale.

The general archive of photographs grows and changes as new discoveries or donations are added, or as changing technologies offer different kinds of images. It can also change when communi-

Women and child in parlour, circa 1895.
Region of Waterloo, Doon Heritage Crossroads

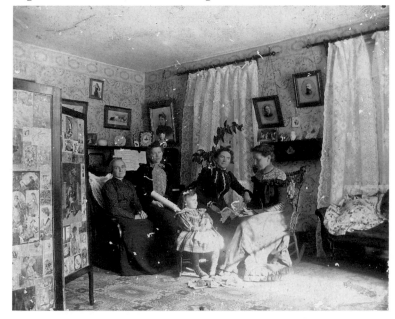

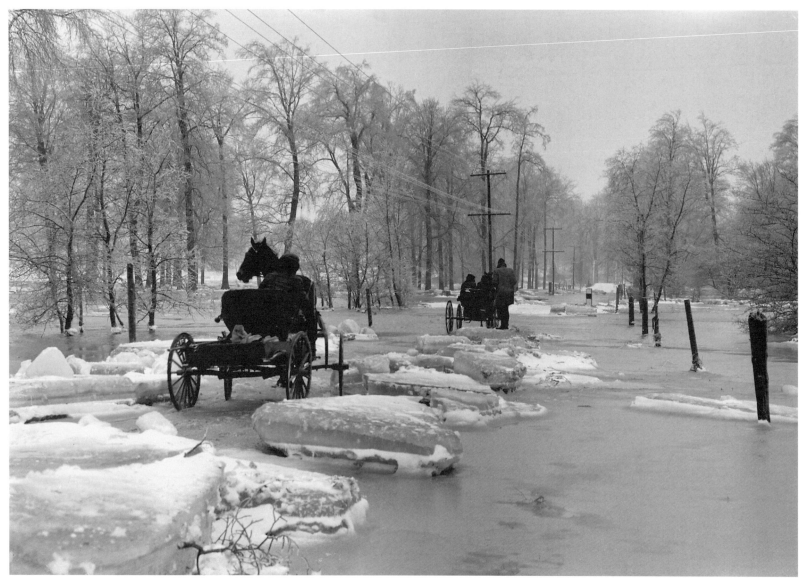

From the late forties to the mid-fifties, David L. Hunsberger's photographs of Old Order Mennonites and Old Order Amish appeared in newspapers and magazines. His images became familiar at a time when travellers visiting Waterloo County in significant numbers were attracted by the distinctiveness of these people. Wearing traditional dark clothing, travelling by horse and buggy, and known for their adherence to centuries-old beliefs and customs, members of the two groups have been easy to identify, although they represent only a small proportion of the county's Mennonite population. That Mennonites, including those with broader views, were not commonly in favour of photography has

meant they are not as well represented in public collections as other segments of the population. Thus, in addition to their aesthetic appeal, Hunsberger's photographs represent an important facet of county life.

This image of Mennonite buggies finding a way through ice thrown across the road by the spring floods of 1954 exhibits a simplicity of composition splendidly contrasted with the ornate world of winter beauty.

Buggies on the Three Bridges Road, near St. Jacobs, 1954.
Photo by David L. Hunsberger

3

The Lay of the Land

The Grand River, the defining physical feature of Waterloo County, follows a winding route from north to south. As it makes its way toward Lake Erie, other rivers join it: the Conestoga River northeast of Waterloo; the Speed River at Preston; and the Nith, which moves along the western edge of the county, meets the Grand further south. Surrounding terrain rises and falls over the contours of glacial deposits — moraines and drumlins and sandy hills — giving the horizon a fluid profile against the more constant sky. And among the rolling hills, some rise above the rest as landmarks: Chicopee Hill near Bridgeport, Pinnacle Hill at Doon, and the hills at Baden.

View from Doon Pinnacle, 1935-36.
Kitchener Public Library

Carl Schaefer, a teacher for many summers at the Doon School of Fine Arts, drew attention to that village's hill when he described a day's painting in August 1958: "I've done several great long stretches of country with a narrow sky, blazing wheat fields giving off a sound like a bell of brass ... I painted the long lower slope of Pinnacle Hill, two versions, and they have a particular meaning. That long slow beautiful contour, uninterrupted."[vi] The visual impression of the hill has been diminished by development over the years since then with the loss of the foregrounding spread of empty fields, but the contour he spoke of remains uninterrupted.

Waterloo County is a territory of surprises, where meandering roads, bending over a slope or twisting along the valley of a creek, can suddenly open upon a farm, a hamlet, or even a small lake. Both of these images hide something. In the photograph of the hill on McDougall Road, which lies immediately to the west of the University of Waterloo, a farm road appears, only to immediately curve away and disappear. And that view was half a century ago; now it has slipped out of sight forever, under the streets and gardens of the expanding city. The Old Order Mennonite farm, with its characteristic windmill, nestles just over a small rise behind screening trees, only partially visible.

McDougall Road, Waterloo, circa 1950.
Local History Department, Waterloo Public Library

Old Order Mennonite farm, Waterloo County, circa 1960.
Mennonite Archives of Ontario at Conrad Grebel University College

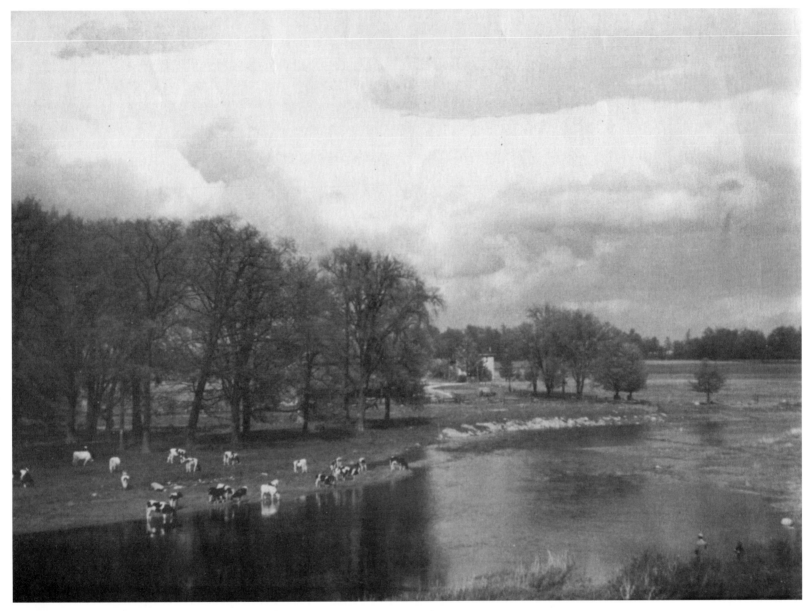

Since 1990, the Grand has been a Canadian Heritage River. Once avoided for its levels of pollution — a consequence of industry, farming, population growth, and indifference — and feared for its raging flood torrents, it has become a stunning setting for water sports, hiking, and nature appreciation. Always, it has been a beautiful river.

The Grand River near Conestoga, 1940.
Waterloo Historical Society

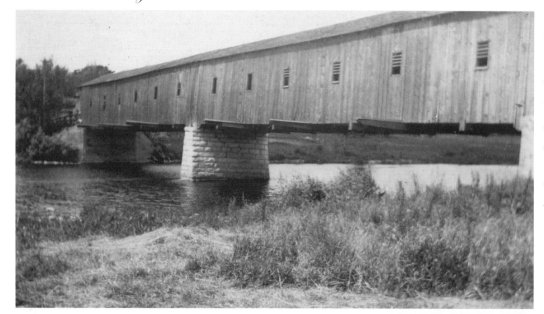

Built in 1881 and dubbed "the kissing bridge," the covered bridge in West Montrose is the last remaining structure of its kind in Ontario. The roof and sides, which protect the bridge from the elements and slow deterioration, are also thought to shield timid horses from the sound of running water.

West Montrose covered bridge, June 1937.
Waterloo Historical Society

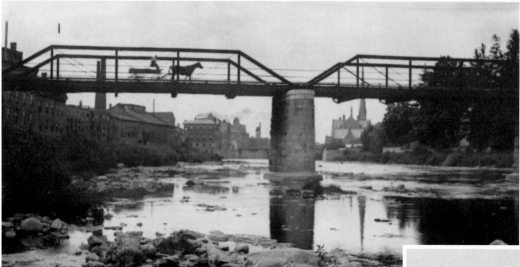

Though a few iron bridges remain on less travelled roads in Waterloo County, these two are among the many that are gone. This photograph was taken from north of the bridge, near the present Park Hill dam.

Bridge over the Grand River, Galt,
July 1910.
William James Topley, 1845–1930/National Archives of Canada/PA-009745

The supporting piers of the Blair bridge were left standing in the river when it was dismantled in 1957. An earlier covered bridge was destroyed by ice in 1857.

Bridge at Blair, circa 1900.
Kitchener Public Library

Woodland scene.
Local History Department, Waterloo Public Library

American photographer Diane Arbus, with an astute sense of her craft, claimed, "A photograph is a secret about a secret."[vii] A useful phrase for most photographs, it matches the mood and subject of this image particularly well. The woodland scene is from the Waterloo Public Library's mysterious glass negative collection: we know nothing of its subjects —even their faces are in shadow. What we can recognize is the lively dance of light and shadow typical of Waterloo County woods.

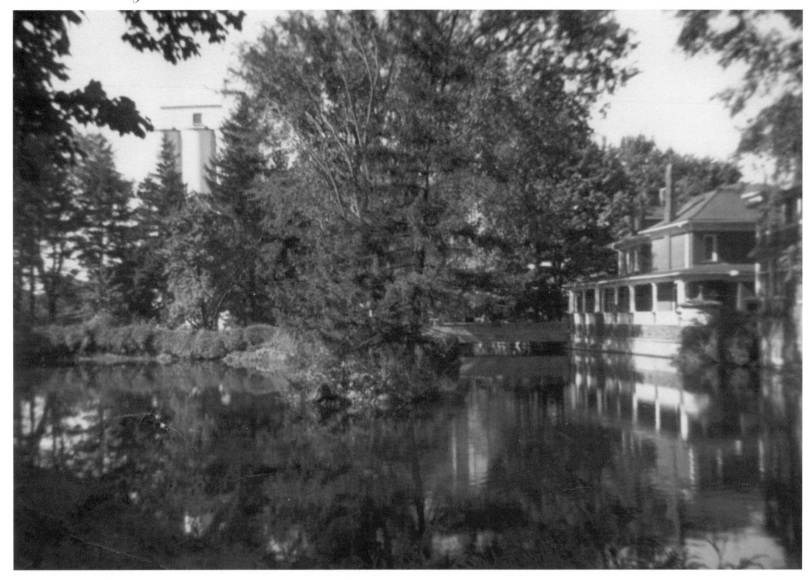

This photograph holds another sort of secret. In 1950, this idyllic view of the mill race was only possible from the Speed River bridge, looking downstream. Esson's view of the Speed River dam is directly upstream. The verandah of the house at right remains, but the little bridge, leading to an island in the river and barely discernable at the far end of the verandah, is gone. In the upper left, the silos of Dover Flour rise behind the trees and mark the site where John Erb began to mill flour in 1807, saving settlers a long trip to Dundas and establishing the nucleus around which the town grew.

Mill Race at Preston, circa 1950.
F. Dewdney Collection

4
Living on the Land

How settlers lived on the land, how and where they chose to farm, and where they built their towns put in place the early features of our cultural landscape and set down a blueprint for later development. What we see today is the cumulative result of habits, issues, and decisions over the past two centuries. In these photographs, taken between 1860 and 1930, the mills that were necessary from the start were still in use, as were methods of cultivation that lasted until well into the twentieth century — and that, in some parts of the county, remain unchanged.

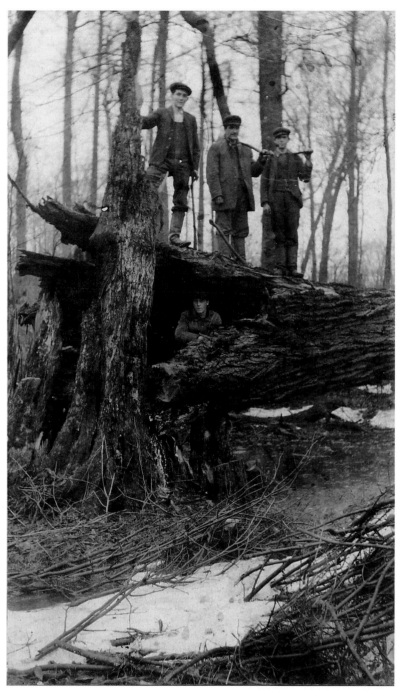

Three horse team pulling a binder, Wellesley Township, circa 1910.
Laura Heipel Wagner/Region of Waterloo, Doon Heritage Crossroads

Laura Heipel Wagner (1892-1965), an enthusiastic amateur photographer, took both formal and informal portraits in the area around Wellesley and Baden.

Clear imperatives shaped the days of settlers opening up the bush and forest for cultivation. Felled trees kept sawmills humming. Stumps too big to remove were left to rot, with seeds planted in the sun-filled spaces between them. Soon the supply of grains was abundant. With fast-flowing rivers and streams as a ready supply of power, gristmills and sawmills became thriving enterprises, and villages grew around them. When markets opened for surplus wheat and factories sprang to life to make furniture from local wood, the settlements prospered and grew.

Four men on & in a tree trunk, possibly New Germany (Maryhill), circa 1905.
Region of Waterloo, Doon Heritage Crossroads

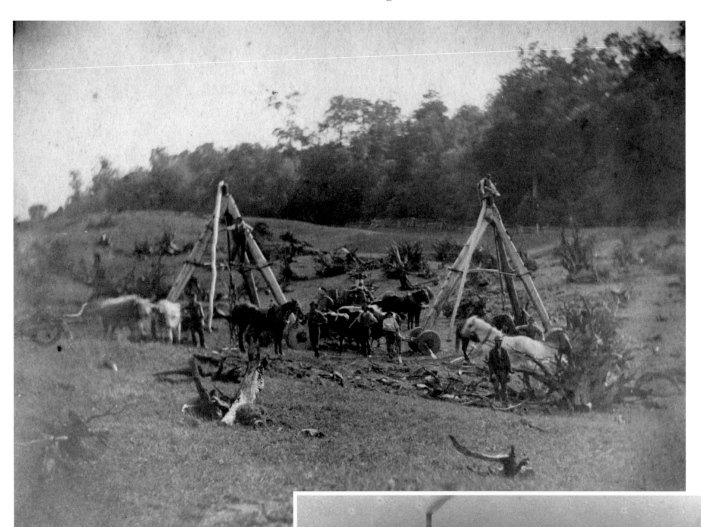

Pine stump-pulling, Waterloo Township,
circa 1860.
Kitchener Public Library

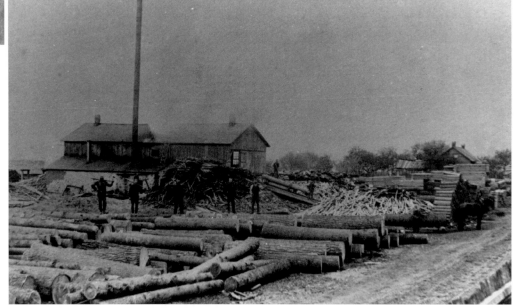

Roseville sawmill, early 1900s.
Waterloo Historical Society

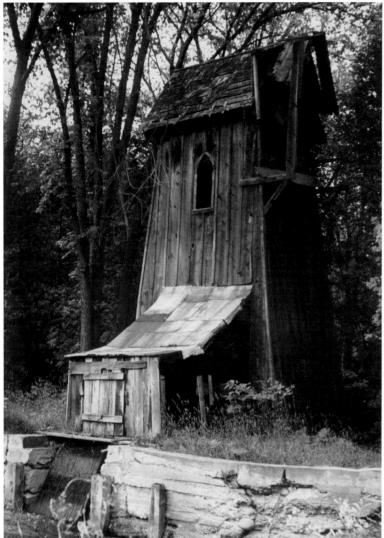

The Sheaves Tower in Blair still stands in woodland beside a quiet road. Easy to reach, with parking for a few cars, its fate is a chronicle of changing attitudes to local history and the built environment. Technologically innovative when new in 1876, it housed a turbine, downstream from the gristmill, to trap the power of falling water a second time and transfer the energy back upstream by cable. In disuse in the 1950s, but silhouetted against the trees in decaying splendour, it lured straw-hatted painters into the summer sunshine with their easels. Now, another half-century on, restored and cloistered behind trees, the tower rests noiselessly by its stream, and Buddhist monks from the village pass by on their daily walk.

Sheaves Tower, Blair, circa 1930.
Waterloo Historical Society

Winterbourne Mill, 1892.
J. R. Connon / Waterloo Historical Society

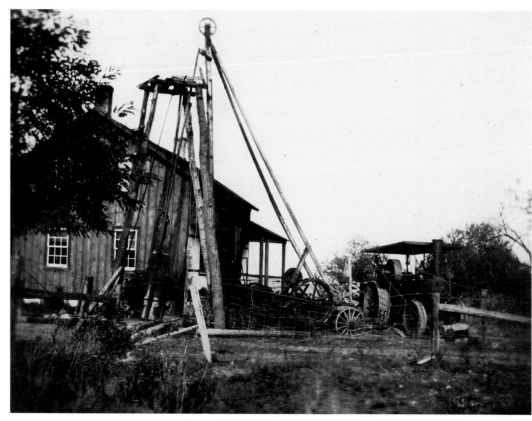

This contraption for drilling wells, its wooden poles, wheels, pulleys, and belts combined in sculptural patterns, is evidence of ingenuity, enterprise, and hard work. Well-drilling may be common still, but this procedure and the equipment for it are unfamiliar. The configuration of farm equipment spread across the road in the next photograph is even less familiar. Similar photographs, taken at several places in the county, suggest the event was as visually astonishing at the time as it looks a century later. The event appears to demand an unusual combination of patience and dexterity from horses, drivers, and villagers alike. The Massey-Harris binders being picked up would have arrived by train at the nearby station to the lower right of the image. All but the central farmer have dismantled their new equipment and loaded it in their wagons.

Well-drilling, near Bloomingdale, circa 1910.
Region of Waterloo, Doon Heritage Crossroads

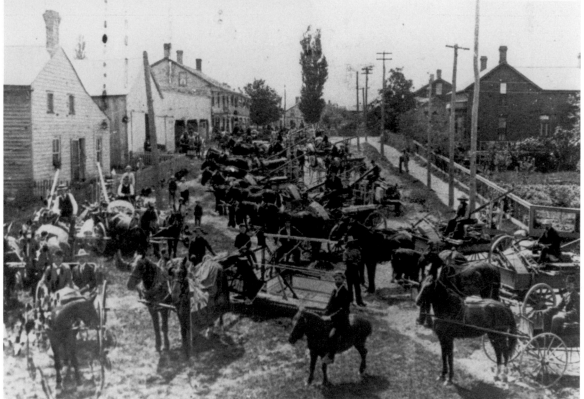

Picking up a shipment of farm machinery, Blair, June 1, 1901.
Kitchener Public Library

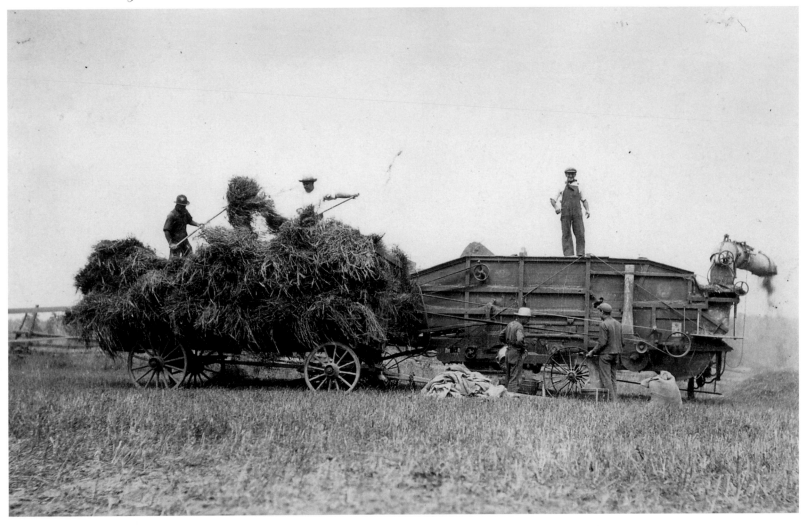

The sense of time passing in these photographs of rural agricultural life differs appreciably from our own. Ida Grenzebach Forler's two images of farm tasks — men threshing and women picking potatoes — are focussed with such care that details demand attention; the equipment, the tools, the clothing, the time of day, and the season combine to characterize her world.

Threshing outfit, Hickson, Oxford County, circa 1920.
Ida Grenzebach Forler / Region of Waterloo,
Doon Heritage Crossroads

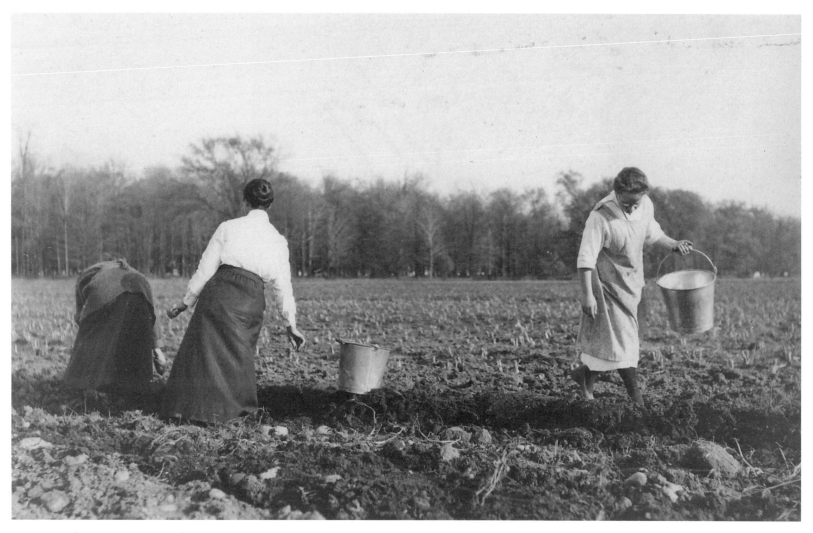

Women picking potatoes at Hickson, Oxford County,
October 13, 1919.
Ida Grenzebach Forler / Region of Waterloo,
Doon Heritage Crossroads

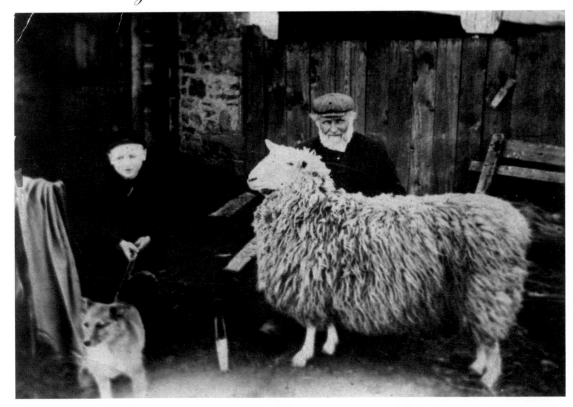

Although we can barely make out Adam Oliver's face, and although that of his grandson is a blur, their direct gaze is accompanied by considerable data. Adam M. Oliver (1828-1917) and his grandson William Charles Oliver (1891-1957) are at the Oliver Homestead Farm in North Dumfries Township. We are told Adam's parents' names, when they arrived in Canada, and that his father was a shepherd in Scotland. Taking that information to the census of 1871, which is online at the National Archives of Canada, a number of Olivers show up as resident in Waterloo County, including his mother, who died in 1877.

Adam Oliver and his grandson, North Dumfries Township, circa 1895.
Region of Waterloo, Doon Heritage Crossroads

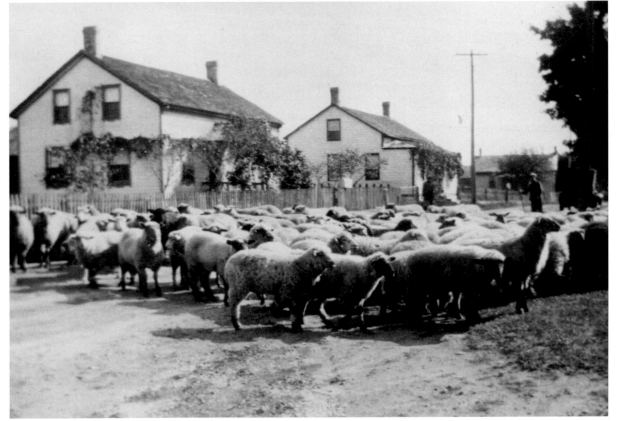

Sheep flock in Bloomingdale, 1920
Waterloo Historical Society

5

From Early Towns to Main Streets

During the first half-century of settlement, the towns where population and commerce might cluster were difficult to predict. Not only had lasting boundaries not yet been drawn by the governments of the day, there was still much to discover. Several events during the decade of the 1850s changed the balance among the towns, setting in place human geographies that, we see in hindsight, led directly to what exists today. When, in 1852, Waterloo County was created with boundaries that would last more than a century and Berlin was chosen as the County Seat, Galt was the larger, more vigorous centre of commerce. Preston, bolstered by an influx of European German immigration, had grow-ing "continental" appeal. Both Galt and Preston, at the southern end of the county, also had advantages of water power that Berlin lacked. According to Adam Ainslie, who sat on the first County Council, Galt was chagrined to be passed over in favour of the small and paltry German village, which was only half its size and not so well linked to the provincial hierarchies.[viii] In cultural terms, though, Berlin was a good choice, and Galt, if temporarily dis-mayed, was well-positioned for future growth. The citizens of Berlin, who had lobbied hard for the benefits of political power, represented the county's predominantly German population; the city, centrally located, would serve them well. In 1856, the Grand

Trunk Railway put Berlin on its Toronto-Sarnia route, cementing the town's prospects, and soon steam power supplied Berlin with the energy source it lacked. By 1900, Berlin was well on its way to becoming the county's largest city. Aside from these main centres of population, a web of smaller towns and villages dotted the county, serving local rural populations. Most continue to fulfill that same function.

In photographs taken within a decade on either side of 1900, towns in Waterloo County bear a clear resemblance to one another. Yet each had unique bonds to the landscape: it may have lain by a river or around and over hills. Many grew at a crossroads, or beside one of the major roads driven across the Great Lakes peninsula. Perhaps the success of a mill or some other industrial project attracted significant numbers of immigrants.

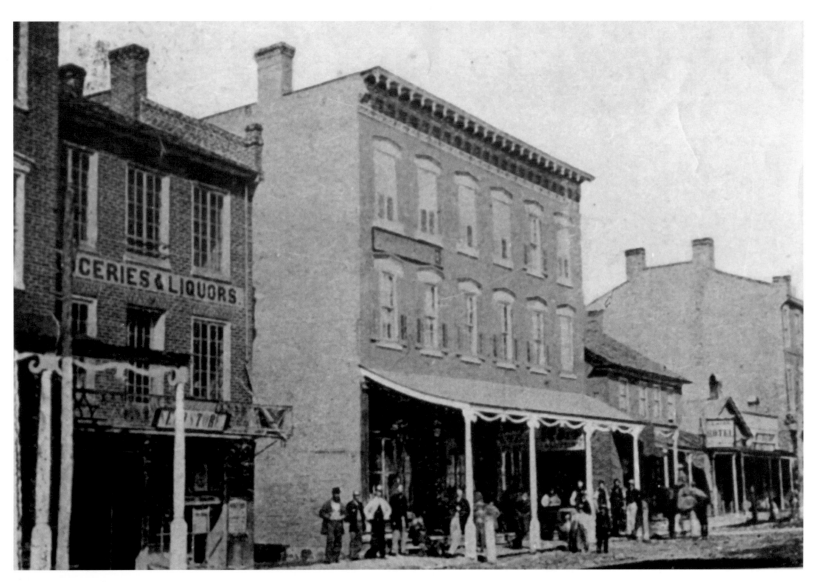

King Street, Berlin, circa 1865.
Waterloo Historical Society

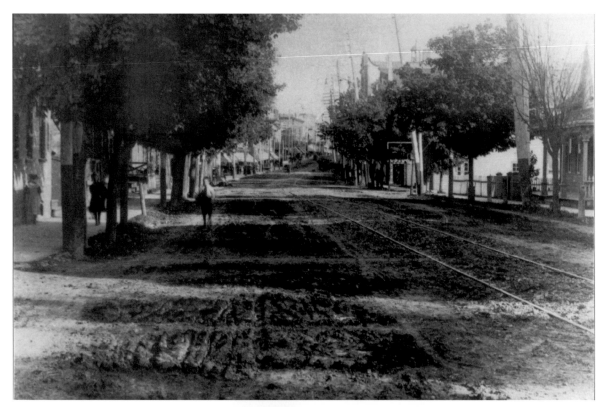

King Street, Berlin. View to the east from Water Street, looking toward the business district of Berlin, 1896.
Kitchener-Waterloo *Record* Photographic Negative Collection, Dana Porter Library, University of Waterloo, Waterloo, Ontario N2L 3G1

King Street, Berlin, July 2, 1906. H. J. Woodside/National Archives of Canada/PA-016644

In the photograph of Berlin, dated 1865, the facades lining the main street are much like those on Queen Street in Hespeler in 1907, forty years later. Indeed, that style still decorates towns across the county. In 1896, the corner of King and Water Streets in Berlin is treed, with rail tracks running down the centre of the unpaved street; James Esson's photograph of Preston in 1905 shows just these features. But by 1906, in the centre of Berlin there are hydro poles and no trees, and instead of boardwalks, there are higher, firmer sidewalks. What these juxtapositions point to are common sensibilities and similar approaches, but quite different rates of growth.

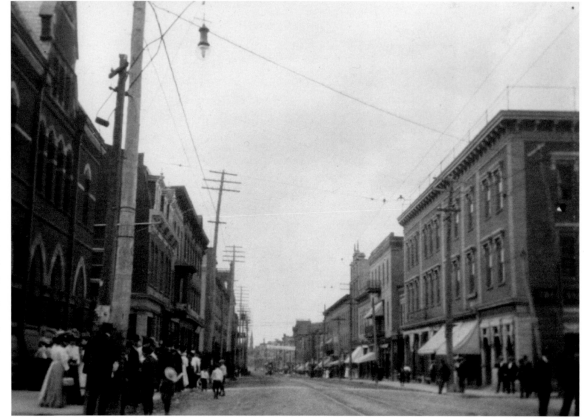

Of two images of Waterloo's King Street, one shows road workers laying track for the street railway, with some familiar architectural patterns on the buildings behind them. The other is of Snider's Mill and the crossing gates of the Grand Trunk Railway, now the CNR tracks. It was not uncommon in Waterloo County's towns for retail, industry, and housing to be set close to one another and to remain that way, for the most part, until needs changed late in the twentieth century.

An artist visiting Kitchener-Waterloo from the American southwest in the mid 1970s characterized what she saw here as "a grey-green industrial landscape." I needed to see the green-green of Vancouver before I began to understand her. And before her phrase was tolerable, I had to discover that it is precisely that grey-green that turns our rolling farmland, peppered with wood lots, into an endlessly layered vista, one that fades to soft blue-grey at the hori-zon. As for the industrial landscape she saw so clearly, I had simply taken it for granted as an inevitability of manufacturing strength that it would have been kinder for her to ignore.

Now I see those aging brick walls differently. General sensibilities have changed. The zest of postwar expansion for modern design has yielded to an affection for the shapes, colours, and solidity of the past. Often a sign of decline, of marked decay amidst a changing economy, old factory walls are what American cultural landscape essayist J.B. Jackson has described as necessary ruins. He maintains that the deterioration of nineteenth-century industrial sites and their rediscovery and subsequent revitalization for other uses (commonly as residence lofts) not only enriches our surroundings, but the process of recovery itself sustains a precious source of well-being, a vibrant link to an era no longer functionally connected to our own.[ix]

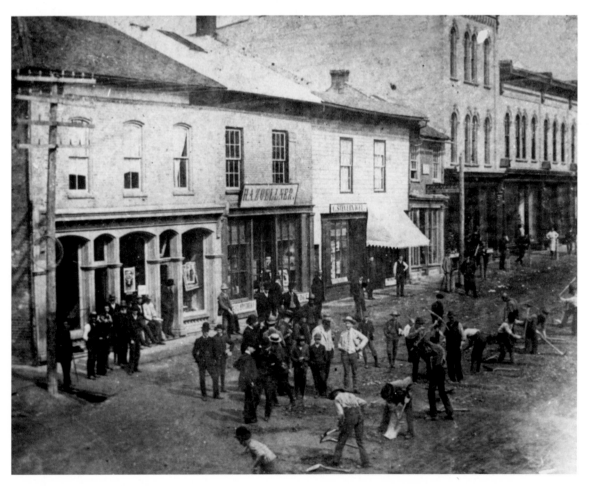

Road crew laying track for the Berlin-Waterloo Street Railway lines in front of the City Hotel, King Street near Erb Street, Waterloo, circa 1890.

Local History Department, Waterloo Public Library

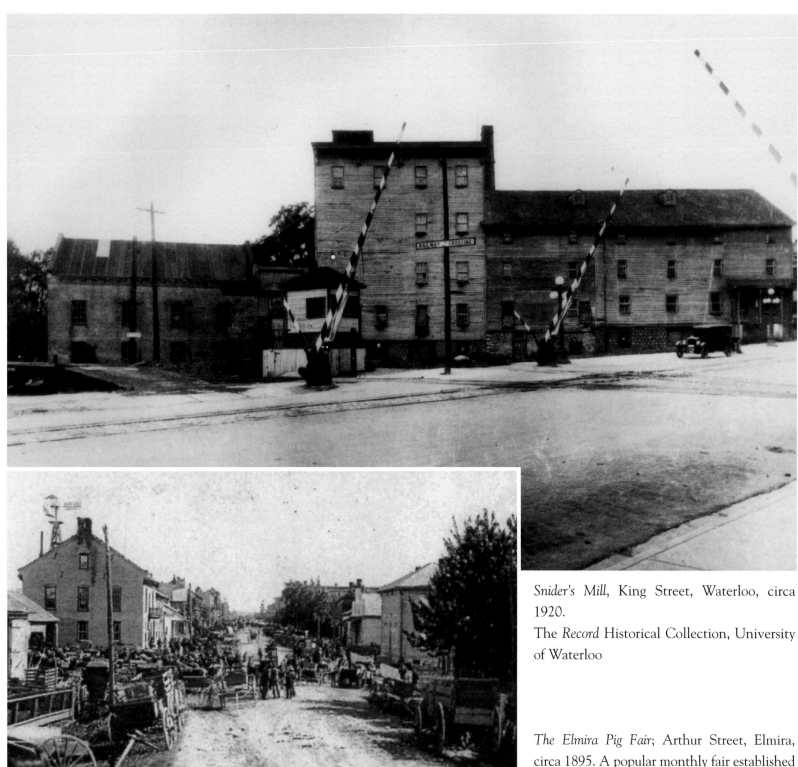

Snider's Mill, King Street, Waterloo, circa 1920.
The *Record* Historical Collection, University of Waterloo

The Elmira Pig Fair; Arthur Street, Elmira, circa 1895. A popular monthly fair established in 1865, it continued through to the 1960s.
Waterloo Historical Society

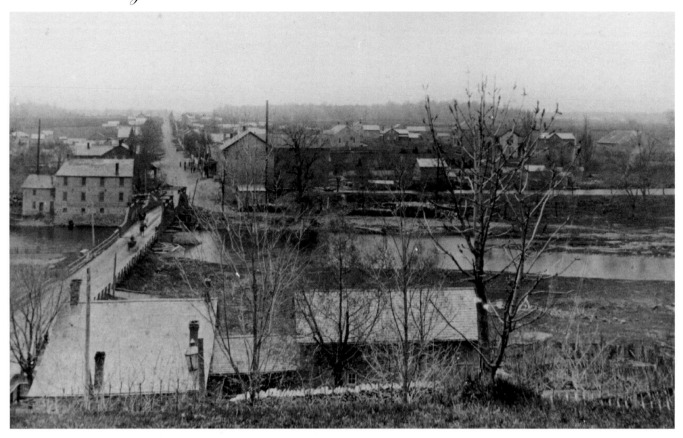

Village of St. Jacobs; view to the south taken from north of the Conestogo River, 1887. Kitchener Public Library

William Street, Wellesley, circa 1905. The post office and shoe store where Ida Grenzebach Forler lived is on the far side of the street, under the fourth roof from the edge of the photo.[x]
The Lemp Studio Collection, Tavistock /Region of Waterloo, Doon Heritage Crossroads

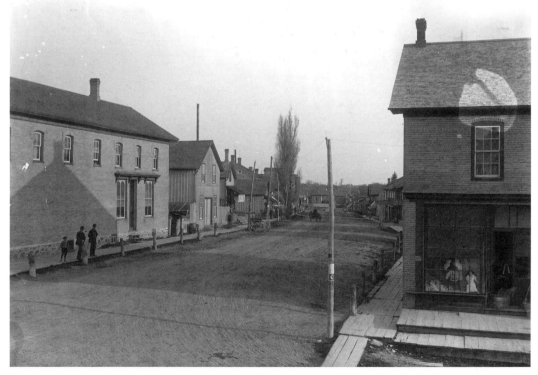

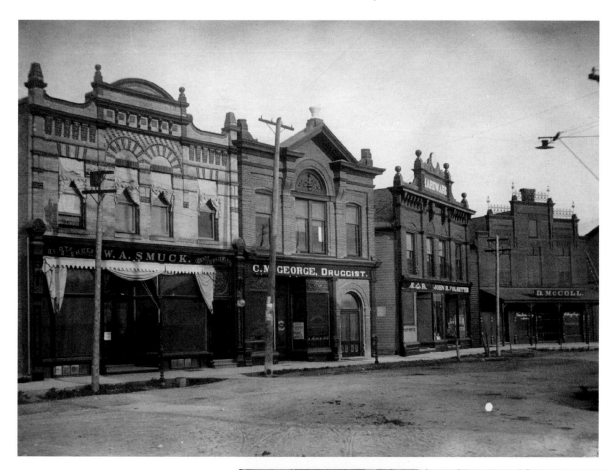

Northumberland Street facades, Ayr, circa 1906. The shops in view are, from left to right, W.A. Smuck, boots, shoes & gents furnishings; C. McGeorge, druggist; John R. Folsetter, hardware and post office; and D. McColl, general store.
Waterloo Historical Society

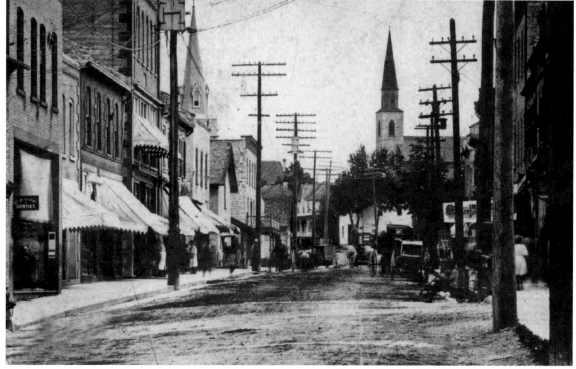

Hespeler, 1907.
Waterloo Historical Society

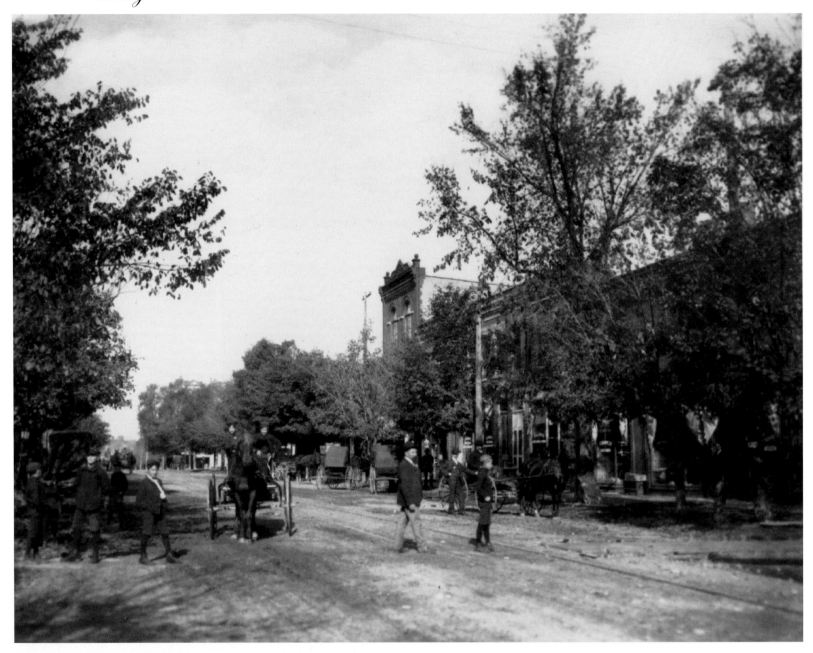

King Street, Preston, 1905.
James Esson/ National Archives of Canada/PA-029084

In his *Reminiscences of the Early History of Galt*, 1880, James Young wrote that "the natural beauty of Galt and its surroundings has been much admired, and seldom fails to arrest the attention of strangers. It can boast little, perhaps, of the grand or sublime in Nature, but its scenery may be described, nevertheless, as strikingly picturesque and pleasing."[xi] He did regret that the first row of buildings were not planned to face the river across a "boulevard or ornamental space" set up on either side. He hoped to avoid what we see in John Boyd's 1915 photograph: factories with their backs to the river, closing off a view of the water from many parts of the city. As it has happened, many of the riverside factories have become visually fertile ruins, and now the river, revitalized, is much more evident, with lofts and parkland making good use of the distressed walls.

The intersection of Main Street with the Grand River, a powerful crossing with hills to the east and west, marks the centre of the town. With the business section on the east side and Queen's Square to the west, a fruitful tension exists that lends the bridge a measure of configuring grace.

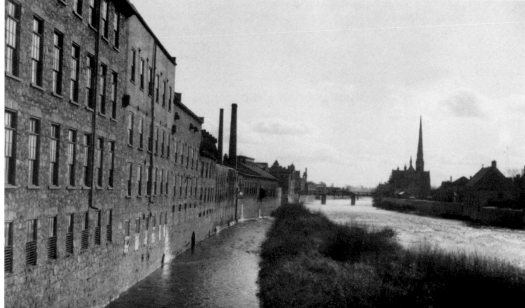

Factories on the Grand River at Galt, December 9, 1915.
John Boyd, 1865-1941/National Archives of Canada/PA-072456

Galt, looking west along Main Street from the hill on the east side; Scott's Opera House on Queen's Square appears at the terminus of Main Street. August 1898.
Taylor/National Archives of Canada/PA-143220

Roschman's Button Factory, Waterloo, 1900. Rudolph Roschman is standing on the platform of this modestly trimmed, utilitarian building, set beside Grand Trunk Railway tracks. At this date, more than one hundred men and women were employed making buttons (from ivory nuts and sea shells), cufflinks, and buckles. The renovated building is now an arts centre.

Local History Department, Waterloo Public Library

An industrial building by the Grand River in Galt, 1900–1925. In the last decades of the twentieth century, buildings like this began to disappear from city cores. Now imaginative uses are fournd for them. Across the river, another building — like this one a persisting remnant from the textile industry — has become the University of Waterloo's architecture school.

Albertype Company/National Archives of Canada/PA-032476

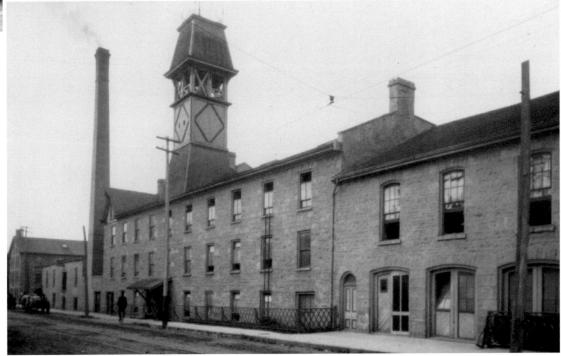

6

Plain and Fancy: Buildings of Consequence

Main streets thrived on commerce, served as principal routes through towns, and responded to changes in the larger economies of trade and taste. They bustled, more or less, depending on the size of the town. Schools, churches, and government buildings, intended to represent more lasting values and more secure in their appeal, had an entirely different presence.

The earliest schools, built of logs, were replaced by sturdier structures as population demanded and prosperity allowed. In rural areas, many of the schools built near the middle of the nineteenth century remained virtually unaltered until, as a consequence of post-war expansion, they were abandoned in the 1950s. Photographs of these schools, with all of the pupils in just a few rows, recall another era — different educational goals, longer days in the sun.

The architecture of urban schools gave expression to the importance attached to education and to the institution designed to dispense it. Of the three buildings pictured, all similar in design and all built of enduring grey granite, two survive and one, Galt Collegiate Institute, remains a secondary school.

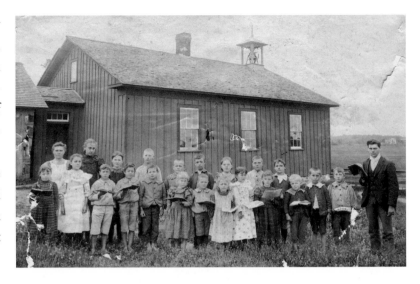

Rosebank School, Wilmot Township, circa 1872. This board and batten school was a renovated version of the early log school built in 1846. It was replaced by a red brick school in 1908 and closed in 1966. Waterloo Historical Society

St. Jacobs school interior, "the little room," 1867. Waterloo Historical Society

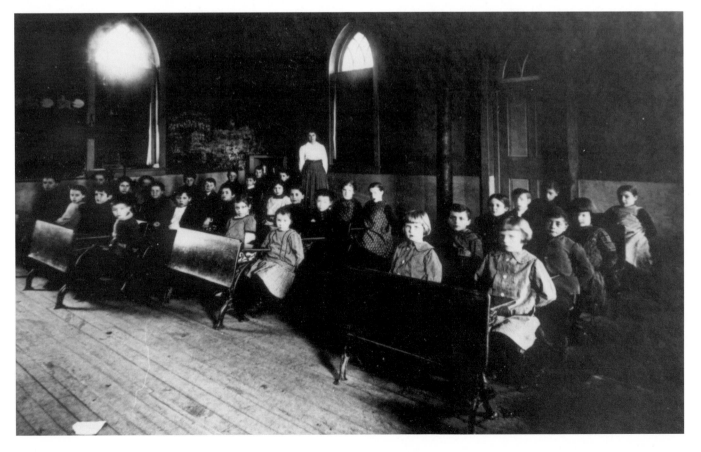

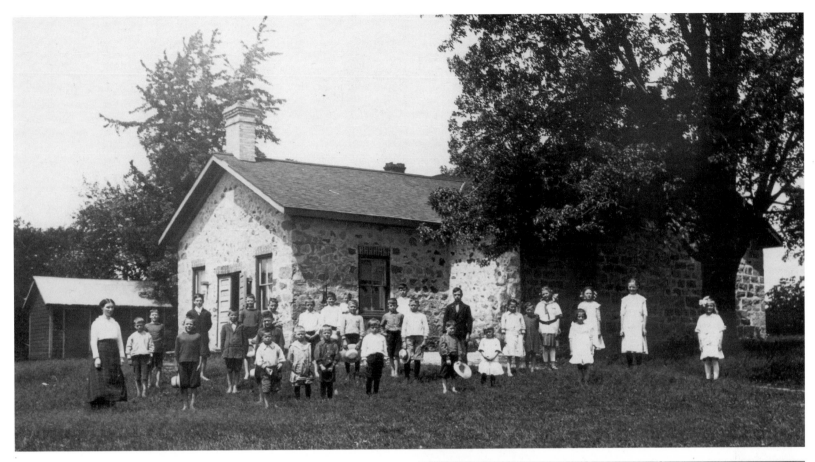

Riverside School, North Dumfries Township, circa 1913. Originally built of logs in 1848 and replaced by this stone structure in 1858, it closed in 1951. Because the school was located on the west bank of the Grand River, a footbridge was built for pupils from the east side to walk across.
Waterloo Historical Society

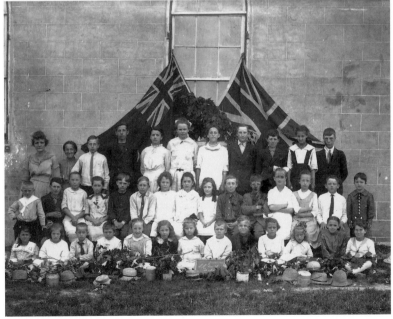

S. S. # 18, New Prussia, Wilmot Township, June 21, 1917. The flags in this photograph by Laura Heipel Wagner create a more elaborate impression than most school photos. They may be an indication of her artistry or, perhaps, a gesture of patriotism in wartime.
Laura Heipel Wagner/Region of Waterloo, Doon Heritage Crossroads

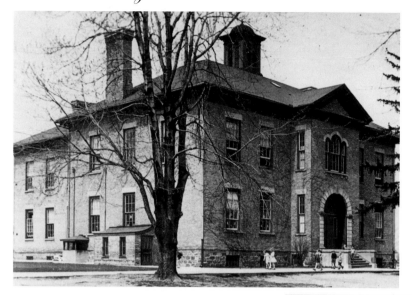

Central School, Waterloo. This was the third of four schools on the same site. The original log school, built in 1820, has been preserved in nearby Waterloo Park. A second school, built in 1840, was replaced by this one in 1845, and this in turn was replaced in 1952. Local History Department, Waterloo Public Library

Preston School and Central Park, Preston, 1905.
James Esson/National Archives of Canada/ PA-029071

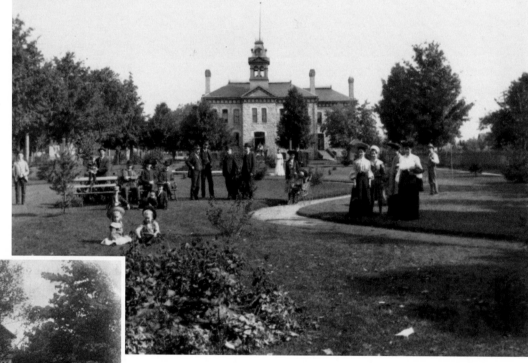

Mr. Tassie's School, Galt, 1902. Under Mr. Tassie, from 1853 to 1881, the grammar school in Galt was renowned and drew students from across Canada, even from the United States. Kitchener Public Library

In Waterloo County, the simplicity of a white frame Mennonite meeting house signals the presence of a community shaped by faith and obedience. Describing Old Order sentiments at the turn of the century, historian Frank H. Epp chose these words:

> All frills and luxuries were avoided, while a premium was placed on productive work during weekends and abundant socializing on Sundays and other church holidays. An existence in many ways austere and limited, the old order way of life none the less produced a people unusually industrious and temperate, peace-loving and tranquil, benevolent and kind, well-mannered and pious. All involvement with the outside world was avoided, and this became possible in an economy nearly self-sufficient and a community both closed and content.[xii]

Just as the Mennonite meeting house represented a refined simplicity, so medieval Gothic churches built across nineteenth-century Ontario were faith statements. With spires reaching heavenward, they spoke of spiritual values in an increasingly secular world. As houses of God, they offered inspiration and sanctuary. Until skyscrapers reached higher, only steeples soared above the trees.

Conestoga Meeting House, near St. Jacobs, spring 1961.
Photo by David L. Hunsberger

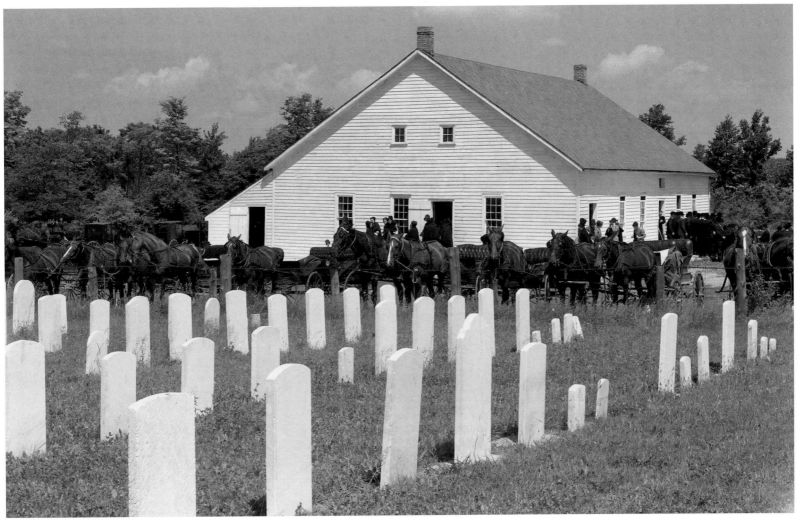

View of Presbyterian churches and Queen's Square, Galt, 1892.
G. R. Berkeley?/National Archives of Canada/PA121776

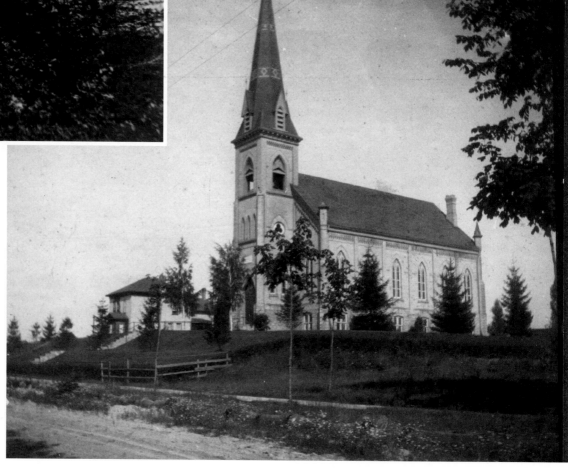

St. Louis Roman Catholic Church,
Waterloo. Built in 1891, St. Louis is
the oldest surviving church in
Waterloo.
Local History Department, Waterloo
Public Library

Churches with towering spires were carefully sited to display their profiles advantageously. That would seem to be the case with St. John's Evangelical Lutheran Church when it was set on a gentle rise on King Street at Bridgeport Road in Waterloo. Built in 1883, it replaced an earlier frame structure; it was destroyed by fire on October 31, 1959.

Wistfulness seems an inevitable companion to old photographs and their promise of a remembered past, even a distant past that can only be sensed. Perhaps I lament the loss of this particular church, which I don't recall ever seeing, simply because it would have been in my neighbourhood, or perhaps because fire, more frequently triumphant in earlier generations, is such a fierce and dramatic leveller. More likely, I suspect, I mind its absence because an architectural void remains where it once stood. The federal building presently on the site is functional, and a genuine product of its time, but it undeniably flattens the hill.

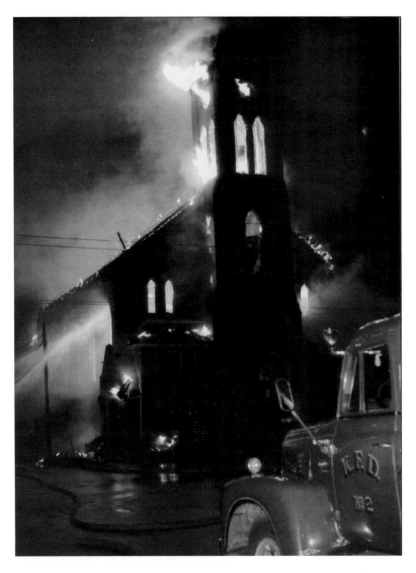

St. John's Lutheran Church destroyed by fire, Waterloo, 1959. Kitchener-Waterloo *Record* Photographic Negative Collection, Dana Porter Library, University of Waterloo, Waterloo, Ontario N2L 3G1

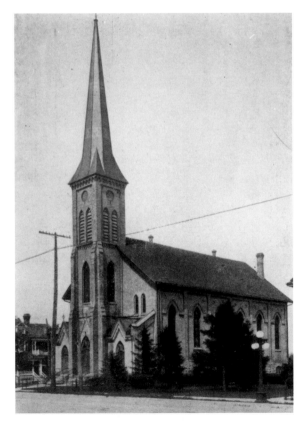

St. John's Lutheran Church, King Street, Waterloo, 1882–1959. Local History Department, Waterloo Public Library

Between Confederation and the First World War, the Department of Public Works supplied towns across the new Dominion with federal buildings designed to cultivate national identity. The familiar Romanesque solidity of these examples (and the county has others) anchored the repetitive tasks of citizenship in architectural tradition. Although the facades are similar, the interior of each building was designed by the department's architects for the specific requirements of its location. In Galt, that included an apartment to house the post-master. Now a pub, the site is visited by the ghost of a young clerk named Emily, whose untimely death ended her secret liaison with the postmaster at the turn of the century.

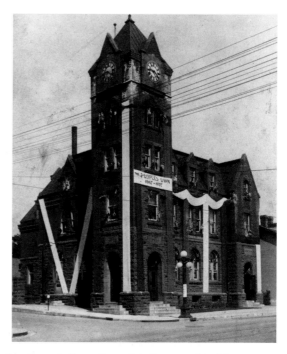

Waterloo Post Office, Canada's Diamond Jubilee, 1927.
National Archives of Canada/PA-057487

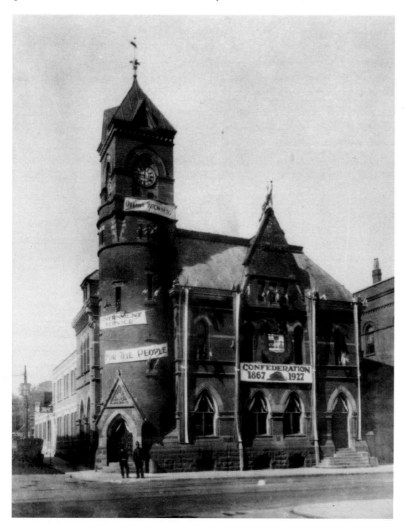

Kitchener Post Office, Canada's Diamond Jubilee, 1927.
The Record Historical Collection, University of Waterloo

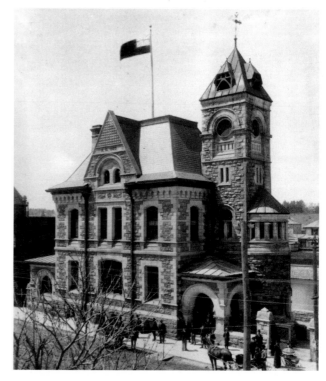

Galt Post Office.
James Esson/National Archives of Canada/PA-126312

These next two photographs illustrate civic architecture based on local tastes. The view down Dickson Street in Galt takes in the Town Hall tower and, beyond that, the market building. Buildings in the foreground display the traditional Scottish facility with design in stone.

View down Dickson Street hill, Dickson Street, Galt. J. Woodruff/National Archives of Canada/C-012122

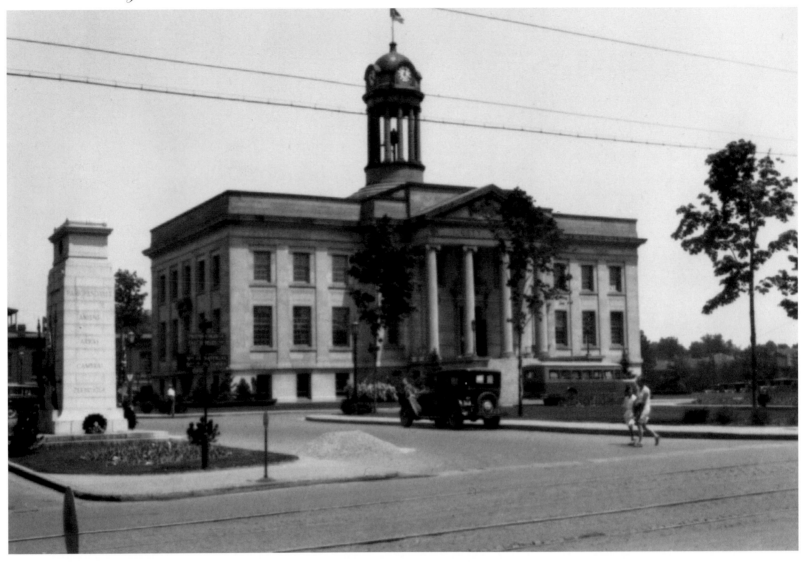

Kitchener's City Hall, built in 1924, was a successful architectural exercise in civic identity. Sited with a square between its classical facade and King Street, and the market buildings behind, it laid clear claim to the city's centre. Nevertheless, it failed to resist development impulses. Though demolished in the early seventies, it has kept a hold on local hearts: the clock tower, preserved and relocated to Victoria Park, has recently become the city's logo.

City Hall and Memorial, Kitchener, June 1930.
John Boyd, 1865-1941/National Archives of Canada/PA-089579

7

At Home

"Home, the site of all childhood's revelations and sufferings, changes irrevocably, so that we are all in some sense refugees from a lost world. But you can't ever leave home either; it takes root inside you and the very idea of self as an entity bounded by the borders of the skin is a fiction disguising the vast geographies contained under the skin that will never let you go."[xiii]

—Rebecca Solnit

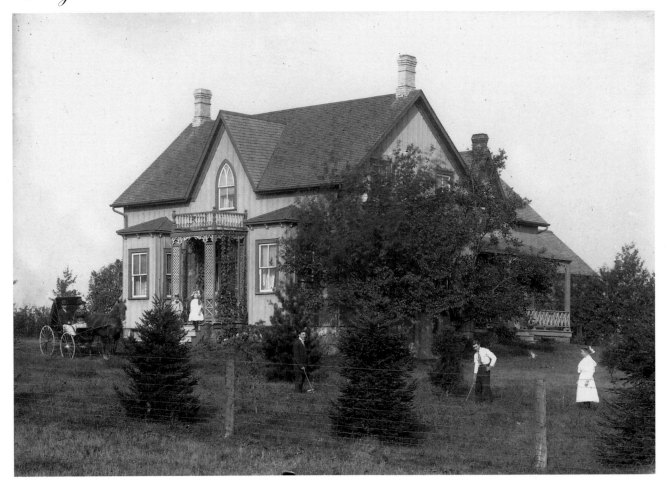

Wellesley Township farmhouse, 1914.
Laura Heipel Wagner/Region of Waterloo, Doon Heritage
Crossroads

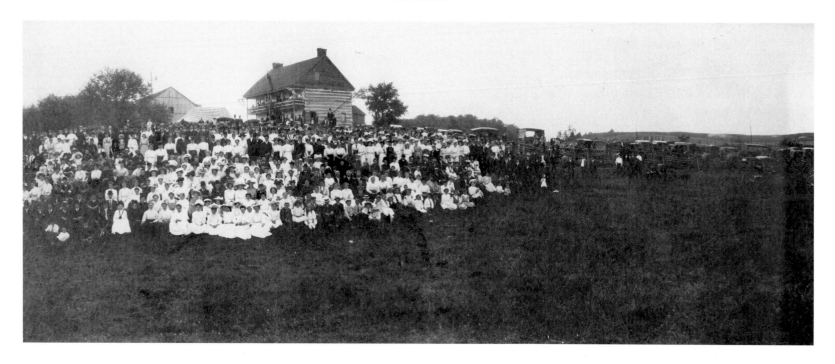

Schneider/Snyder/Snider Centennial Reunion, Waterloo Township, June 22, 1909. The farmstead in the background, built by Christian Schneider in Doon in 1807, survived for 147 years before being demolished in 1954. Immigrating in family groups with the skills, equipment, and financial backing necessary to establish lasting farmsteads, Mennonites have continued to value lineage, as this gathering clearly shows.

Mennonite Archives of Ontario at Conrad Grebel University College

Jacob W. Gingerich Farmstead, Wilmot Township, 1909. Like many others, this farmstead consisted of a two-storey stone house, a large barn, and several frame outbuildings reserved for particular tasks.

Mennonite Archives of Ontario at Conrad Grebel University College

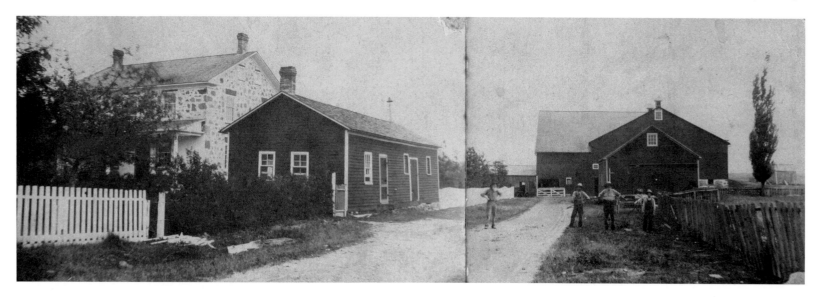

"The landscape of rural Waterloo County is perhaps the most distinctive and long-lasting contribution of these settlers. Their steadings consist of a large Pennsylvania-style overshot banked barn, together with its outbuildings, as a polarity of masculine activity, and a roomy house, with a garden, orchard and additional outbuildings, as a polarity of feminine activity. Around the steading extend the fields, pastures, and woodlots, all fenced and brought together to create a visual image of fecundity, peace, and *Götteseligkeit* — pietistic godliness — in which the pleasures of Paradise are already available for the enjoyment by the blessed in the present world."[xiv]

— Nancy-Lou Patterson,
on Swiss-German Mennonite culture

Old Order farm near St. Jacobs, June 1954.
Photo by David L. Hunsberger

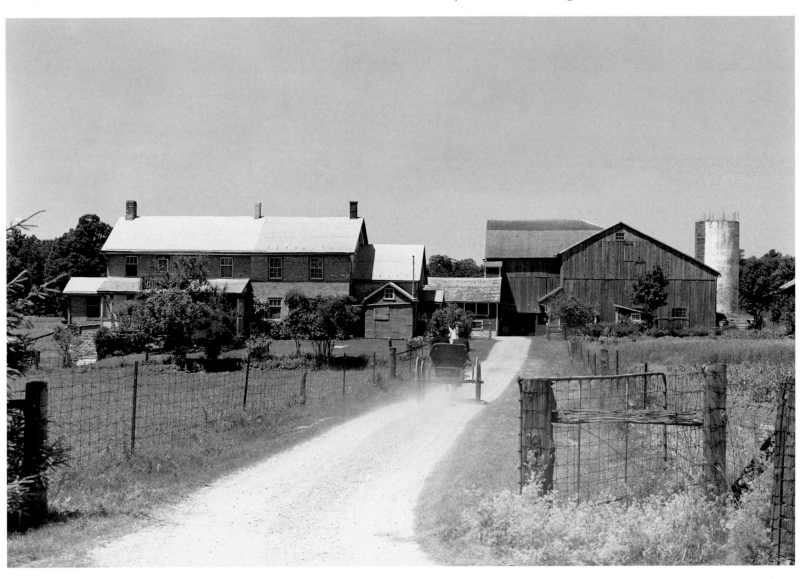

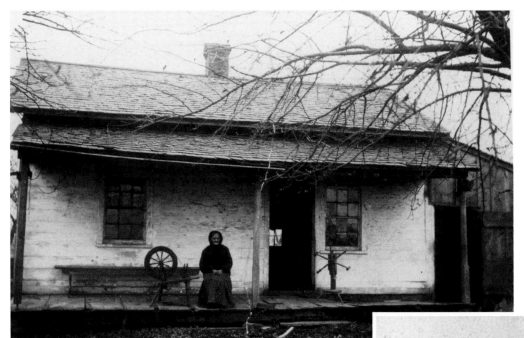

Jacob Bettschen House, Wilmot Township. This was the first frame house in Wilmot Township, having been moved there from a location in Waterloo Township in 1830.
Waterloo Historical Society

Schaefer Residence, 26 Dorset Street, Waterloo, circa 1890. While Dorset Street remains, there is no visible trace of this house.
Local History Department, Waterloo Public Library

Rumpel House, Kitchener. Named Forest Hill when built by Sheriff Davidson in the 1850s, and later the Rumpel family home, this house and garden were on the present site of Kitchener's Cameron Heights Collegiate.
Waterloo Historical Society

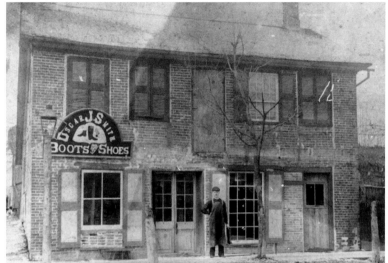

Oscar J. Smith in front of his combined shop and residence, St. Jacobs, 1900.
Kitchener Public Library

Oscar J. Smith's renovated shop and residence, a few years later, St. Jacobs, 1906.
Kitchener Public Library

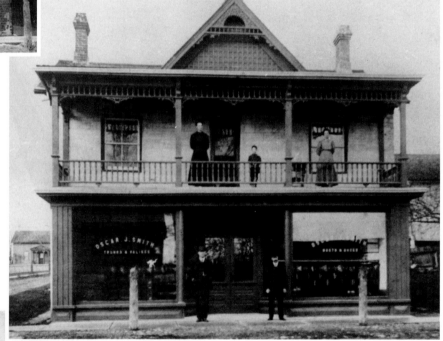

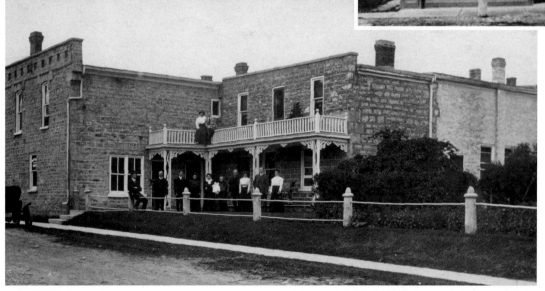

The Henning family in the garden at the rear of their combined grocery store, ice cream parlour, shoe shop, and residence, at the corner of King and Lowther Streets, Preston, circa 1905.
S. K. Walker Collection

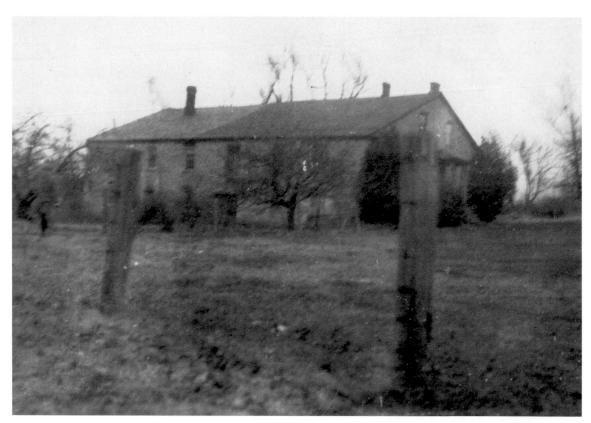

Hexham House, at the time of purchase, Blair, 1925. This property would become my grandfather's "vest-pocket Paradise." When he bought it, the building was already one hundred years old and had served as a tannery, a distillery for a whisky called *Mountain Dew*, and a hatchery for Brook and California Trout, able to turn out half a million fry a year. In 1891, the high dam was built so that electricity could be generated for arc lights on the streets of Preston. For several years from 1906, it belonged to Eugene Langdon Wilks, who intended to use it as a game and fishing preserve and as housing for staff at Langdon Hall.
S. K. Walker Collection

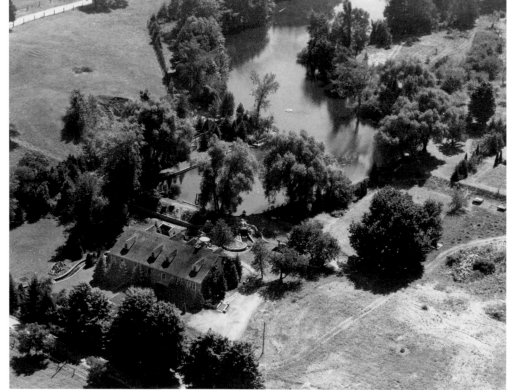

Hexham House, Blair, 1948. This is how the property looked some twenty years later during his retirement. A corner of the four-square garden is visible at the far right. Not so visible are outbuildings, like the two square objects beside the garden, for raising rare waterfowl, peacocks, and other birds.
Ron Nelson/S. K. Walker Collection

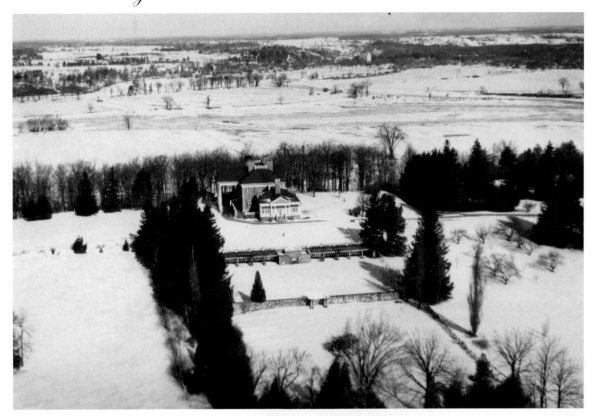

Langdon Hall, Blair, February 1948. Once a country estate and now a country hotel, the property is viewed from the south, looking across the sunken gardens to the house and then over the Grand River to Preston.
Waterloo Historical Society

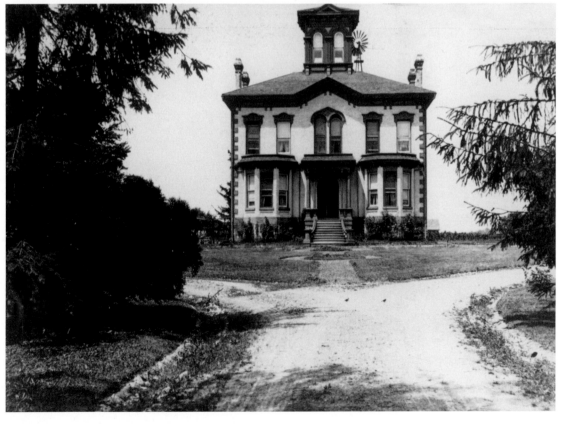

Castle Kilbride, Baden, circa 1900. Built in 1877 by James Livingston, this Italianate Victorian country house is well known in the county for the exquisite images on the painted walls of its elegant interior.
Heritage Wilmot

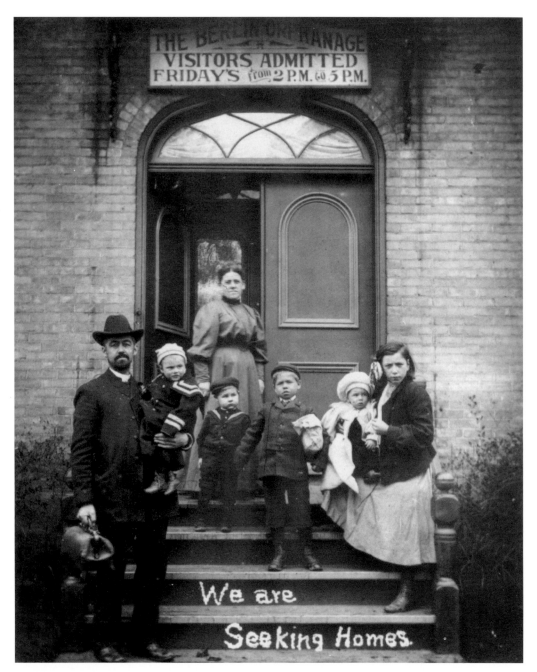

The Berlin Orphanage, a site of childhood's sufferings, June 1907. Attempts to legislate security for the homeless at a provincial level were continuous; so too was the practical work of local charities. Rev. C.R. Miller, at left, a pastor of the Mennonite Brethren in Christ Church in Berlin, worked tirelessly for the establishment of Children's Aid Societies in Waterloo County.
National Archives of Canada/PA-120926

8
Getting Around

The images are still, yet the subject is travel and speed. The journey is about to start, the race about to be run, or perhaps they are already over. In any case, when horses, trains, and cars did stop, the camera could be put to work. Movement was seldom caught by early cameras; instead, there is a blur, or the figure simply disappeared. Nevertheless, imagination responds easily to photographs, and so we infer direction and motion and draw upon memory and knowledge to elaborate what we see.

Whether a photograph can engage other senses may depend on experience. Pictures of sturdy farm horses recall slow trips on empty hay wagons toward summer fields, along narrow and empty roads.

There are smells to be sure, some for sun and some for shade, and the feel of insects. But stronger than these are sounds: the rhythm of horses' feet upon the gravel road, the creak of the wagon, the slap and jingle of harness. Beyond those sounds there is ample silence, sometimes broken by heat-driven cicadas. Never the roar of traffic nor the rhythms of a train on distant tracks.

Road and rail criss-crossed the county, slicing through hills, bridging rivers, and determining where population clustered. This is an inland region; in the early years of settlement, a river ill-suited for navigation and the infamous Beverly swamp blocked access to the open water of the lower Great Lakes. Soon enough, however, roads

pushed through: thoroughfares to serve the province, like the Great Road and the Huron Road, and county roads like Erb's and Bleam's. Then, just fifty years after the first settlers had arrived on trails, the railway era began. Galt gained a branch line to Guelph on the Great Western Railway, and the Grand Trunk Railway passed through Kitchener, turning attention eastwards toward Toronto. In another fifty-year increment, electric trolleys were easing the movement of people and goods between the county's cities. Inexpensive and convenient, this form of transportation carried children to school, commuters to work, and day-trippers to parks designed for their pleasure. The next fifty years encompassed the World Wars; when they ended, it was the turn of the automobile.

For each mode of travel, there has been a time of ascendancy when particular ancillary activities flourished. Blacksmiths, carriage-makers, and horse breeders shaped how people got around until they were edged aside by railway stations, the nodes of long and more comfortable journeys. In their turn, these stops by the tracks gave way to car dealerships and roadside gas stations. Throughout, whatever the means of transportation, the need for road houses and hotels, where travellers could sleep and locals could gather, remained. Some, like the hotels built around the mineral springs in Preston, were a destination in themselves.

By Horse

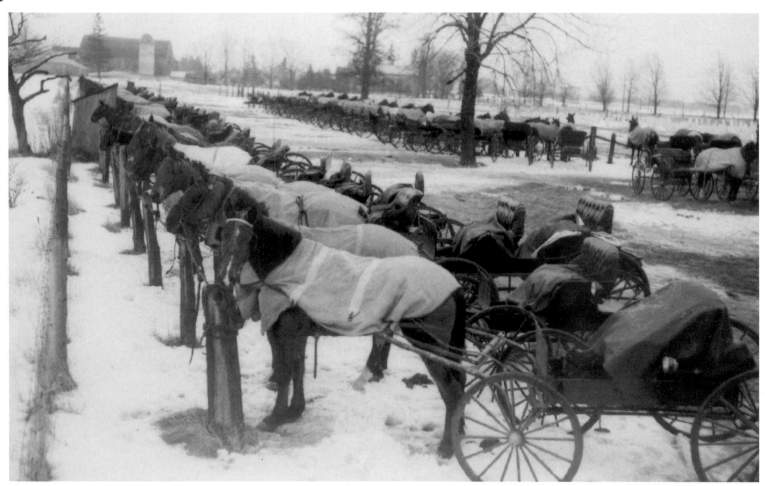

Mennonite buggies in the 1940s.
The *Record* Historical Collection, University of Waterloo

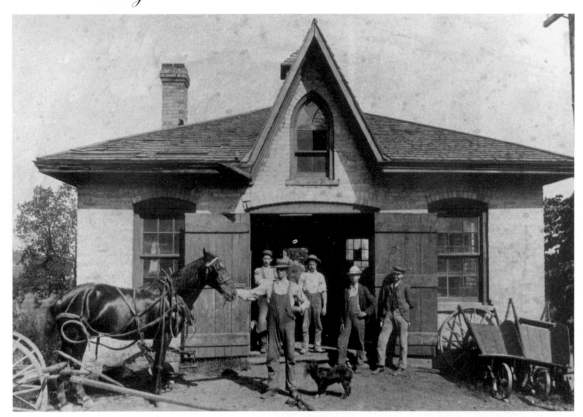

Blacksmith shop, New Dundee, circa 1900.
Waterloo Historical Society

Brubacher Bros. workshop, St. Jacobs, circa 1900.
Carrying on a business begun by their father in the 1860s, the brothers did a good trade in cutters, sleighs, and buggies.
Waterloo Historical Society

Travelling in style. A photo album note points out that the entire family could travel in style on Sundays in this "top surrey." The Peter Sherk and family album. Mennonite Archives of Ontario at Conrad Grebel University College

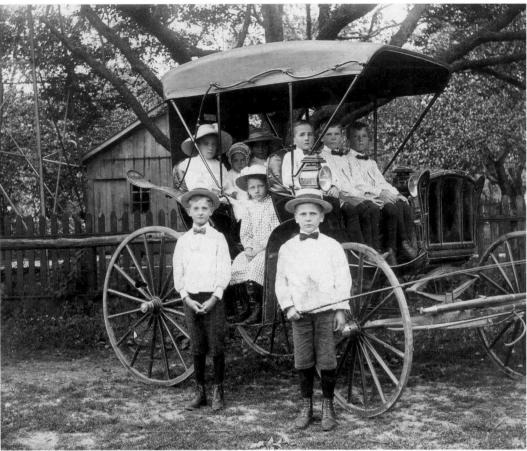

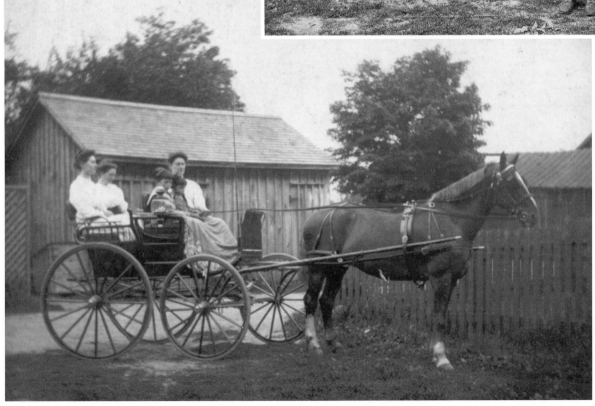

My great aunts: all set to go, Preston, circa 1905. S. K. Walker Collection

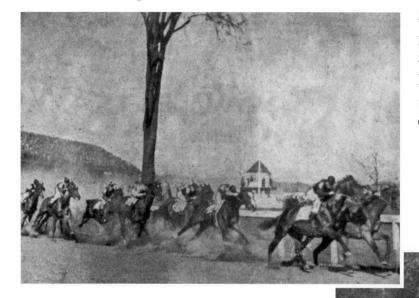

Seagram Stable's "Sally Fuller" won the King's Plate in this 1935 race pictured in the *Waterloo Chronicle*, December 1936. Joseph E. Seagram's thoroughbred stable, set up on Bridgeport Road in 1888, had won fifteen Queen's and King's Plates by the time of his death in 1919. The stable was maintained into the 1970s.
Clara Rutsch Collection

A *prize-winning but anonymous horse*, part of the Kavelman collection of glass negatives.
Heritage Wilmot

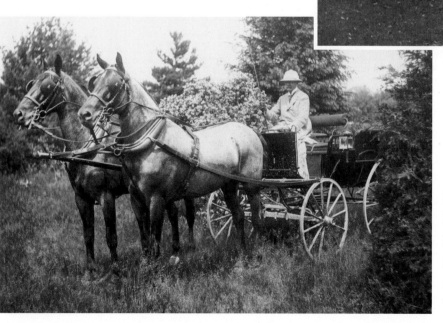

Eugene Langdon Wilks (d.1934), the original owner of Langdon Hall, with a team and carriage. His sister Katherine Langdon Wilks, at neighbouring Cruickston Park Farm in Blair, was renowned for her standardbred horses at the turn of the century.
Waterloo Historical Society

By Steam Railways

CNR 1338 with the Roustabout coming into Galt from Kitchener, February 25, 1955. Dickson Park's baseball scoreboard is inside the fence on the left, above the "G" on the Galt sign. Travelling over the bridge in the background, and about to pull into the Galt Station, is a CPR train from Chicago heading eastbound to Montreal.
Photo by Harold Kinzie

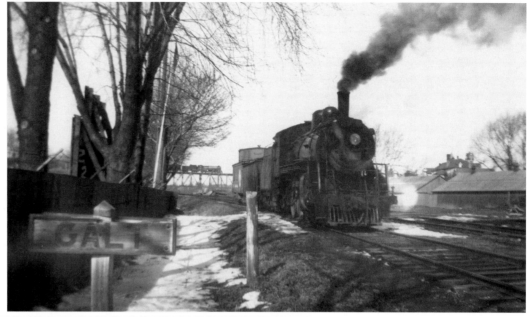

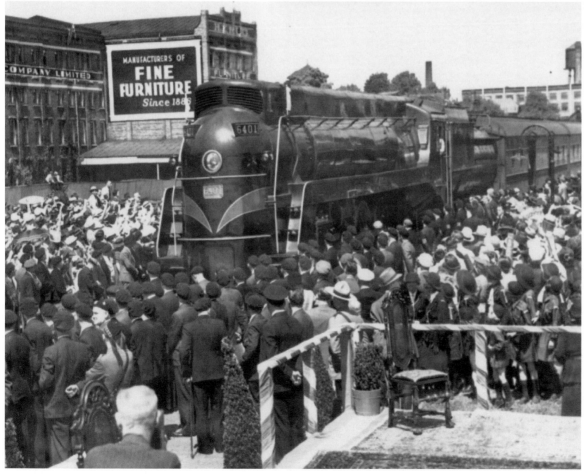

CNR Engine 6401, Kitchener Station, June 1939. This stream-lined Montreal-built engine served as the pilot train for the Royal Tour, pulling into the Kitchener station in advance of the train carrying King George VI and Queen Elizabeth. The Royal Train, CNR Engine 6400, had recently been featured at the New York World's Fair. Canadian Government Motion Picture Bureau/ National Archives of Canada/ C-037607

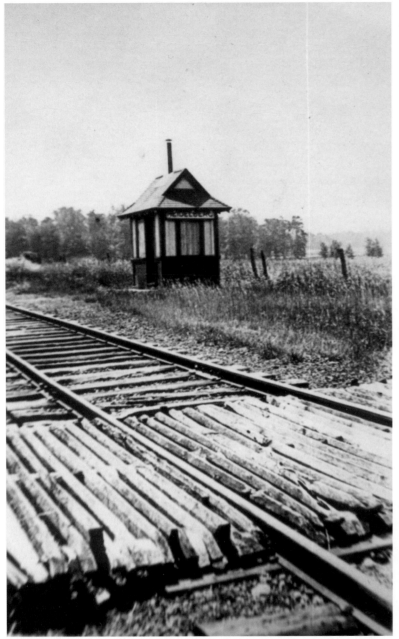

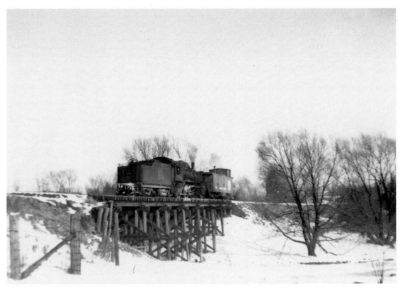

CNR 1338 with the northbound Roustabout at Doon, February 4, 1955.
Photo by Harold Kinzie

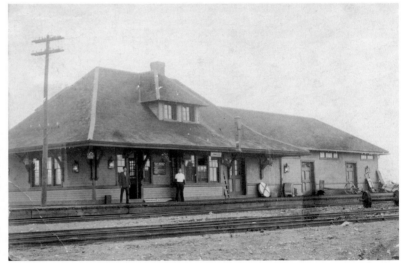

Heidelberg Station, 1935-6. The smallest train depot in Canada, with tiny benches that could barely seat three, it measured five feet square. Just a flag stop, it might nevertheless have had twenty passengers to board in its heyday. Passenger service had already ceased when this photograph was taken in 1928; the building was demolished in 1949. John Steen Carroll/Kitchener Public Library

Linwood Station, 1909. A very familiar design for railway stations. Waterloo Historical Society.

On Electric Interurban Railways

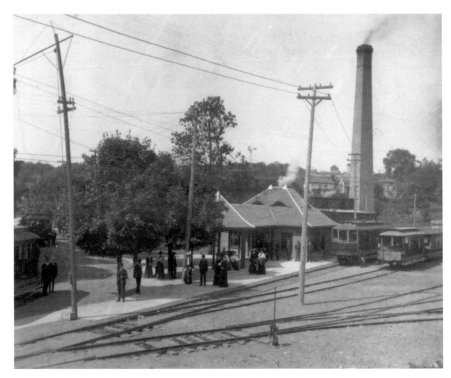

Junction of the Preston & Berlin, and the Galt, Preston & Hespeler Street Railways, Preston, 1905. After a year of operation, the station was already a hub of activity. The famed sulphur springs, whose curative powers drew visitors to the town's hotels, are just a short distance away.
James Esson/National Archives of Canada/PA-029079

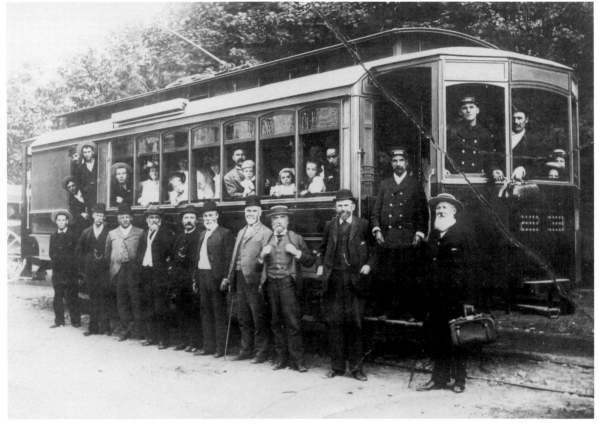

Car 23 was one of two built and ready for the Galt & Preston Street Railway when it began service in 1894. A local newspaper declared this car to be "after the most modern style. ... The seats are finely upholstered; bevelled glass windows decorate the ends and the car contains four electric heaters. Fourteen incandescent electric lights, with very pretty globes, hang from the ceiling, and the car has a seating capacity for about 30 passengers."[xv]
S. K. Walker Collection

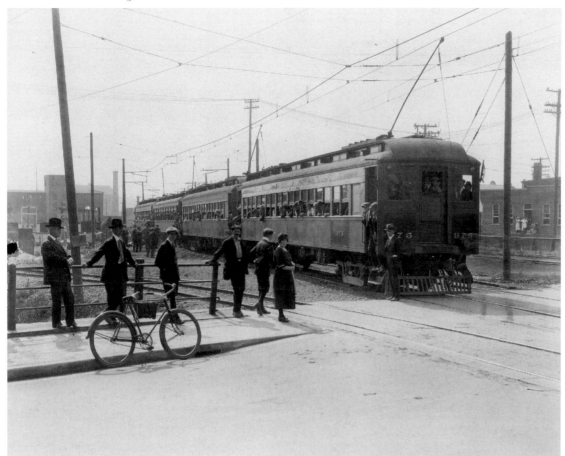

A *day trip to Port Dover*, Main Street, Galt, 1922. A single day excursion from Waterloo to Port Dover, about the cost of a regular single fare, brought carloads of holiday-makers to travel on the jointly operated Grand River Railway and Lake Erie & Northern Railway.
M.A. Van Sickle Collection

Galt, Preston, City & Suburban Transit Co., Limited
GALT - PRESTON
ONE FARE
Geo. B. Batty, President
2816

GALT & PRESTON STREET RAILWAY
Commutation Ticket.
This Ticket is not transferable, and is issued in favor of
Robt R Elliot
No 5 — 1894 Wm H Lutz Sec'y.

Idylwild Park. Another excursion destination, closer to home on the line between Preston and Hespeler, and only accessible by rail, Idylwild boasted pavilions for dancing, picnic places, and a ball diamond. Apparently, it was also blessed with an abundance of mosquitoes.
Kitchener Public Library

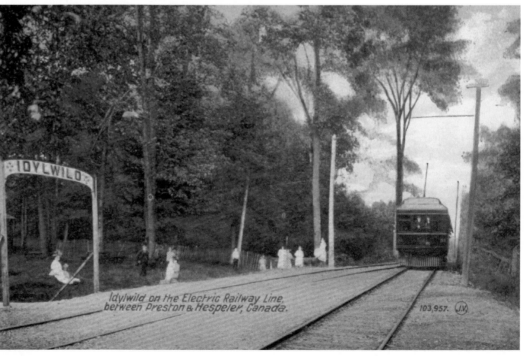

Idylwild on the Electric Railway Line, between Preston & Hespeler, Canada.
103,957.

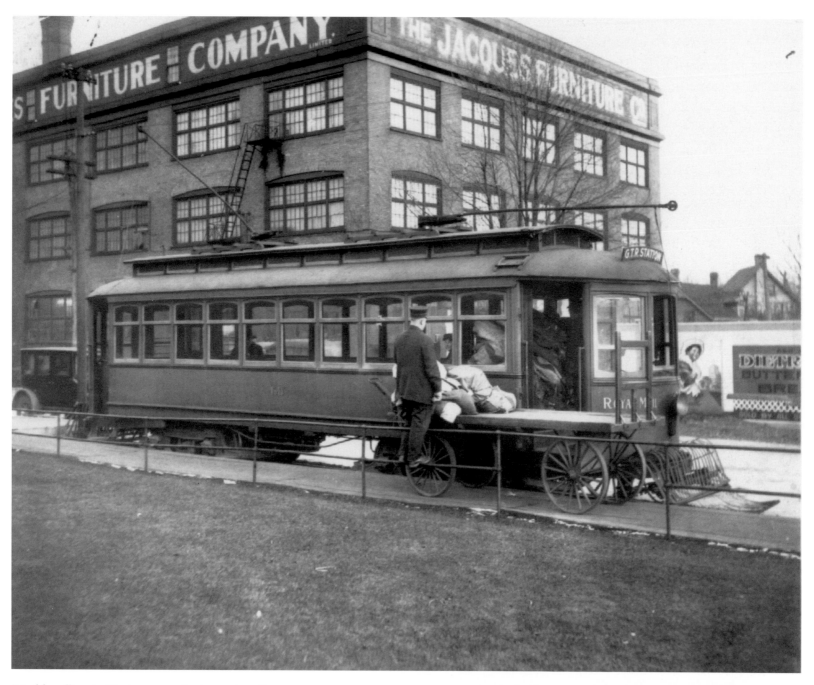

Mail handling in Kitchener on the interurban line.
National Archives of Canada/PA-061563

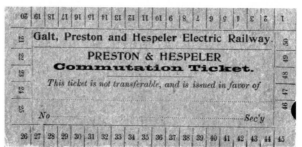

By Car

Motoring in the countryside. The train tracks and hydro poles make this a thoroughly modern jaunt.
Breithaupt Hewetson Clark Collection, University of Waterloo

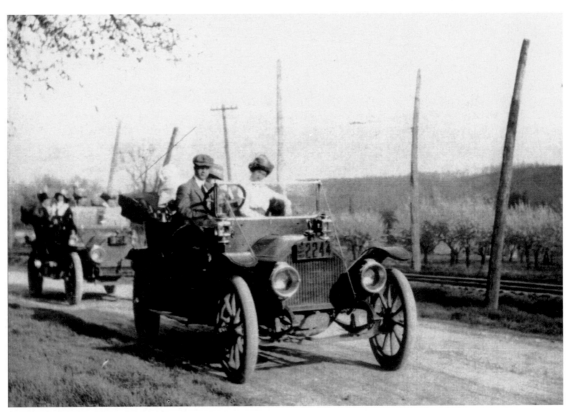

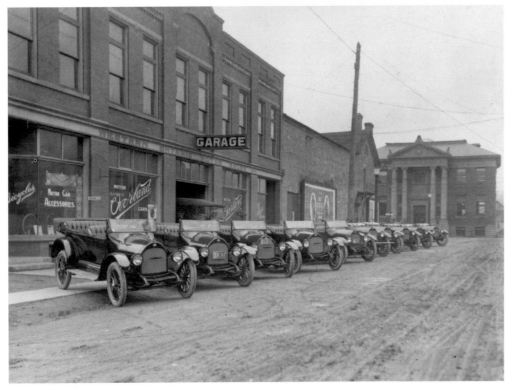

Willys Overland Automobiles, Western Ontario Motor Sales, Galt, circa 1915. A line of ten shiny new cars on an unpaved Dickson Street; the columned facade of the Carnegie Library, with its back to the Grand River, is at the end of the road on Water Street.
National Archives of Canada/PA-143239

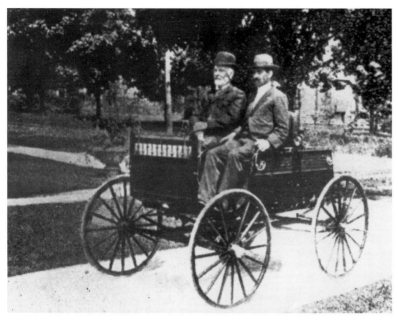

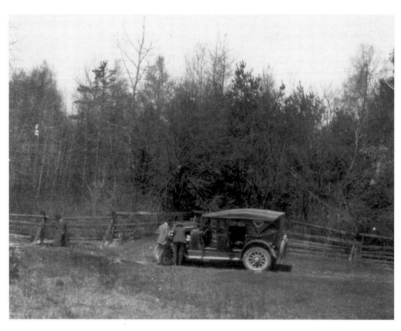

A horseless carriage. This pair, Nelson and Dr. Milton Good, built an early production motor car in 1901 at their LeRoy Manufacturing Company.
Waterloo Historical Society

Checking under the hood, May 6, 1923.
M.A. Van Sickle Collection

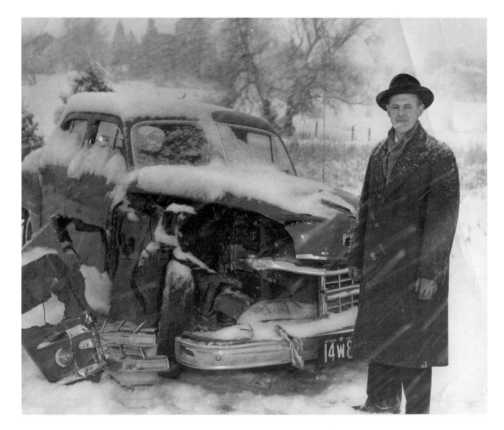

Stopping for a train on a slippery winter road, circa 1950. The Galt-Kitchener CNR train that ran through Blair and Doon was in the habit of making the run to Galt engine-first and doing the return trip backwards. My father, coming down a hill toward the Parkway crossing in his brand new Dodge, saw the caboose and assumed the slow train was moving away. It wasn't. The caboose lost a step, which was replaced for $40, the train had to lead with its engine from then on, my father did something about the car, and I have this photograph.
Kitchener-Waterloo *Record*/M.A. Van Sickle Collection

Stopping for the Night

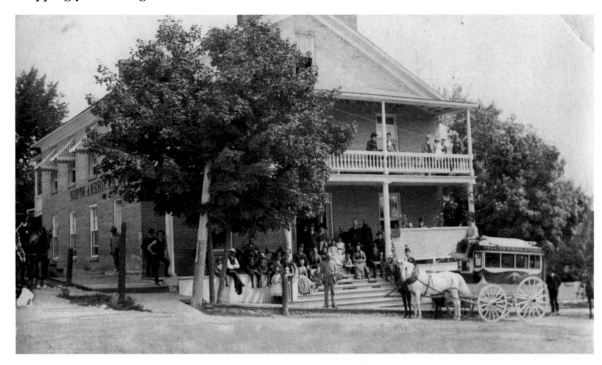

North American Hotel (later the Kress Hotel), Preston, 1880.
Waterloo Historical Society

Lamb's Inn, Blair, circa 1890. A note in pencil on the back of the photograph reads: "notice dad and Elmer with cigar cases in their arms."
Kitchener Public Library

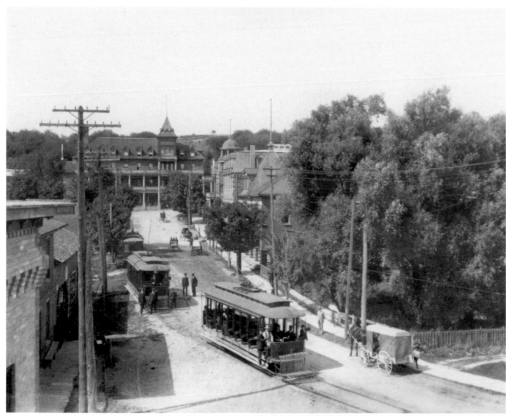

Trolley cars, with the Del Monte Hotel at the top of the street, Preston, 1905. The Del Monte Hotel, with the pointed roof on its tower room, has about it an air of perpetual gentility that time has not disrupted. Often ailing and continually resuscitated, it lives yet and may do so for some time.
James Esson/National Archives of Canada/ PA-029056

Del Monte verandah, Preston, 1905. This Esson photograph captures the Del Monte's gentility at its slow best.
James Esson/National Archives of Canada/PA-029082

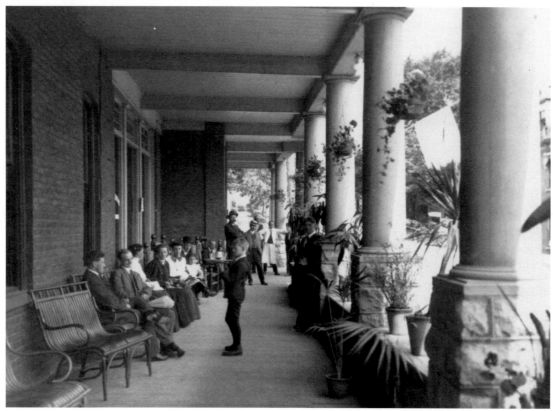

Grand Hotel, Queen's Square, and the Opera House block, Galt, 1900–1925. This photograph positions long absent buildings. The present public library is located on the site of the hotel, at right, and Scott's Opera House is on the left. The city's Crimean War gun and a park bench may emerge from the tangle of lines at the centre of the picture.
Albertype Company/National Archives of Canada/PA-031828

Clerks at a hotel desk in St Jacob's.
Kitchener Public Library

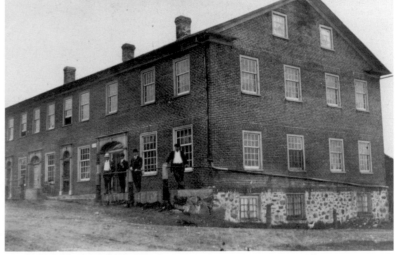

Petersburg Hotel [The Blue Moon].
John Martin, the author and illustrator of a popular sepia-toned *Guide to Waterloo County*, published by the Waterloo Trust and Savings Company in the 1960s, considered this to be "one of the finest and about the last of the great Georgian road houses, with finely proportioned windows and doors, and refined Classical doorways."
Heritage Wilmot

9
To Market

Before Waterloo County had suburban malls and freestanding all-purpose grocery stores, there were downtowns. Small enough to navigate with ease (but crowded on Saturdays), with shops and services for almost everything, downtown streets provided plenty of public space for trading ideas, enthusiasms, and agendas for the following week.

Key sites in the centre of towns were the local produce markets. Galt's market had already settled into place in the 1840s; by the late 1880s, it was in its present quarters. An early attempt to establish a market on the other side of the river was thwarted by vendors and townsfolk who knew where they wanted to be. Berlin's market, like Galt's, was located beside the Town Hall, where, famous for its German foods and atmosphere, it thrived.

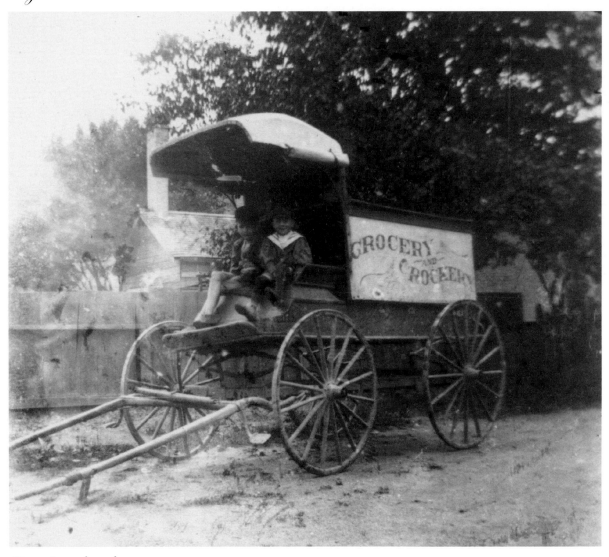

Groceries and crockery.

Local History Department, Waterloo Public Library

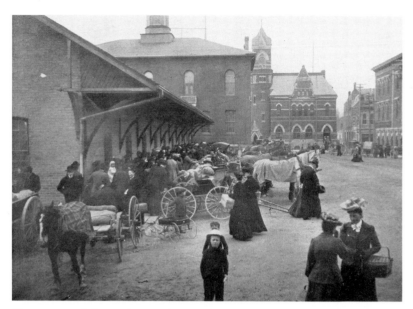
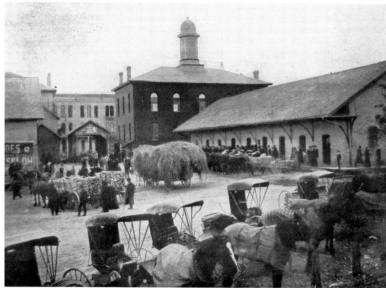

Two views of the Berlin Market published in *Berlin Today* in 1906. In one of them, the former post office building, with its arches outlined in lighter stone, can be seen on the far side of King Street.
Toronto Public Library

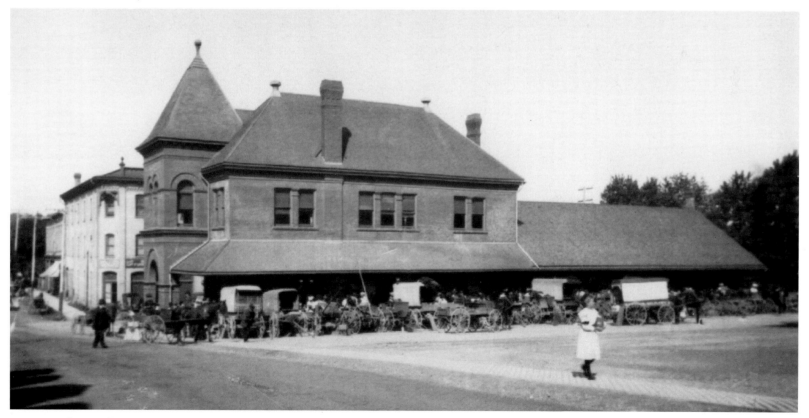

Town market, Galt, 1900–1925.
Albertype Company/National Archives of Canada/PA-032765

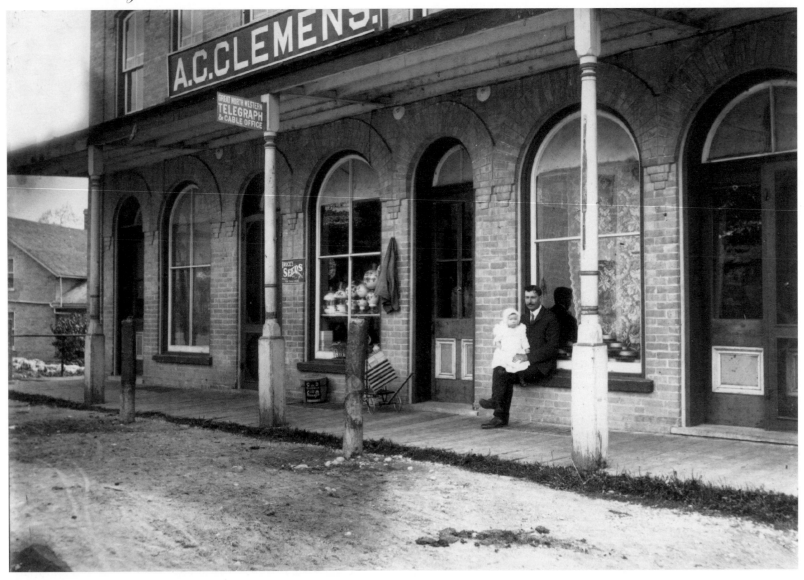

A.C. Clemens, later H. Kavelman & Co., New Dundee.
Herman Kavelman/Heritage Wilmot

General stores in the villages served their customers with a wide selection of goods. For the last half century, at least, Kavelman's in New Dundee has been a county favourite with artists. Still operating as a tea room and gift shop, the building has carried its mellowed wood interior and fine exterior proportions into the new century with a gentle sense of the way things were. The building, here home to A.C. Clemens's general store, was called the Jubilee Block when it was built in 1887 to commemorate Queen Victoria's fifty years on the throne. Herman Kavelman, the photographer, who may be the figure seated with a child on the window ledge, ran the store from 1910 to 1971.

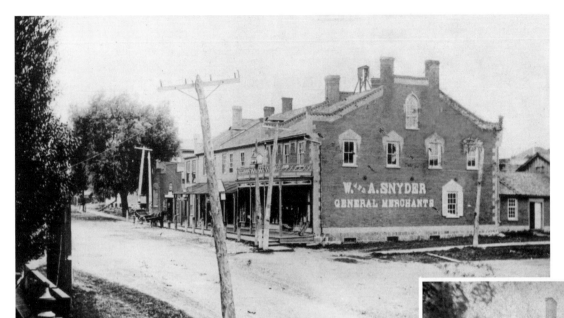

W. and A. Snyder, General Merchants, St. Jacobs, 1895.
Kitchener Public Library

James Hall, Hawkesville. Notes on the reverse of this fading image of the James Hall business in Hawkesville name some of the figures: "Uncle Jim Hall at head of horse, Aunt Kate in doorway, and Father Jacob Shoemaker at right in dark suit."
Waterloo Historical Society

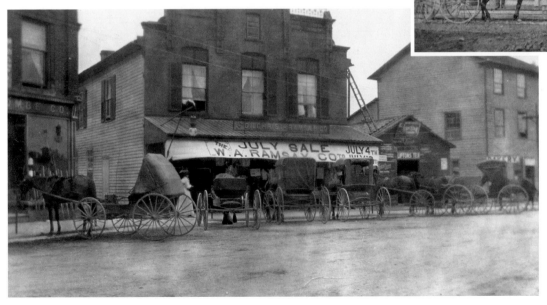

July Sale at Ramsay and Gilchrist, Ayr.
Waterloo Historical Society

That German was a working language in schools, churches, and shops in much of the county until the First World War, and common enough after that, cannot be supposed from many photographs. German names on shops and businesses offer a rare clue. That other groups were immigrating as well is clear from the same evidence. It was at the Roma Theatre, according to Edna Staebler in *Sauerkraut and Enterprise*, that kids in Berlin could see the Phantom Rider on a Saturday afternoon.[xvi]

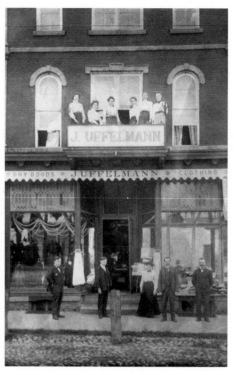

J. Uffelmann, Dry goods & clothing, King & Erb Streets, Waterloo.
Local History Department, Waterloo Public Library

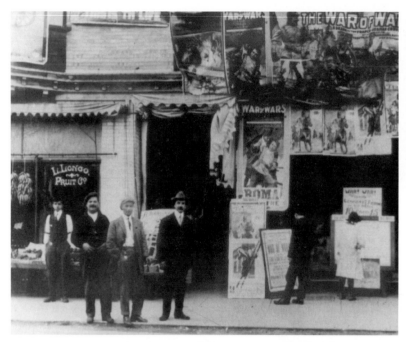

L. Longo Fruit Co. and Roma Theatre, King & College Streets, Berlin, circa 1914.
The Record Historical Collection, University of Waterloo

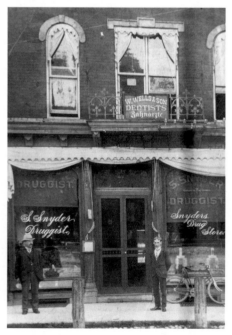

Snyders Drug Store, Waterloo, built in 1857.
Local History Department, Waterloo Public Library

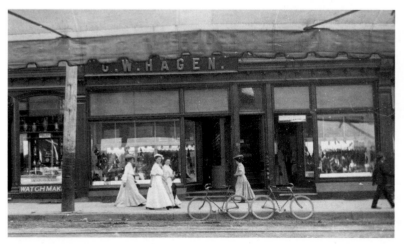

C. W. Hagen, shoe store, Berlin, 1905–06.
Waterloo Historical Society

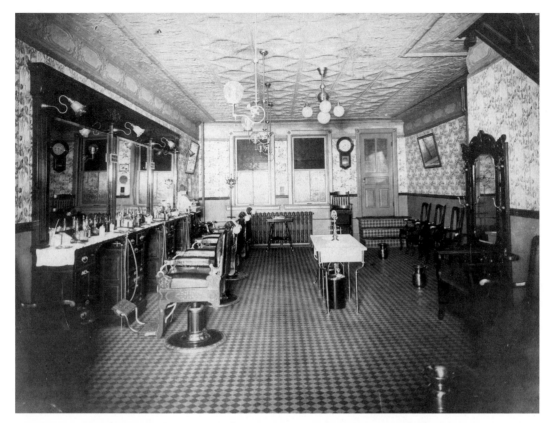

Empty of customers for the photographer, these shops are portraits of downtown space and marvels of intricate organization. Between them they display an abundance of decorative detail: a Coca-Cola sign over the soda fountain, a boldly patterned carpet, tin ceilings, fixtures of all sorts, and a clock in the mirror that reads three-thirty.

Rolling's Shave Shop, Berlin, 1908.
Waterloo Historical Society

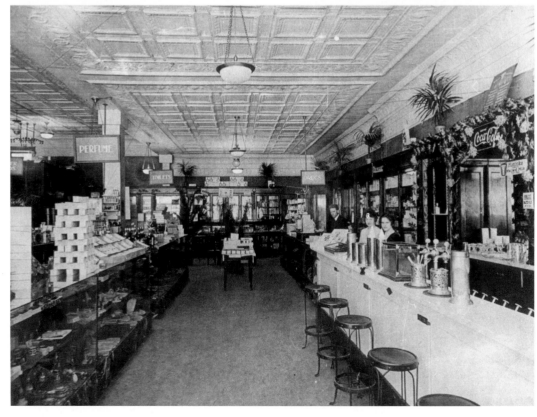

Roos Drug Store, Ice Cream Parlour & Confectionery, Kitchener.
Waterloo Historical Society

According to Mary Ann Van Sickle, great-niece to one of the women at the counter, the women of the Henning family ran the grocery store and the elaborate ice cream parlour. "Patrons entered the ice cream parlour from the back of the grocery store, passing under a large photograph of the family bulldog flanked by the British Union Jack and flags of other nations. Tree-sized rubber plants were set along the windows on one side of the room and a large fan hung from a tin-embossed ceiling to cool those sitting at the heavy wooden tables, each with four heavy wooden chairs. Shining steel fountain fixtures and ceramic nymphs holding scallop shells of fresh fruit adorned a marble counter at the far end. The square grand piano in the parlour, closed and modestly draped with a red-fringed shawl during the week, was opened on Saturday night and musicians gathered to transform the ice cream parlour into a lively dance hall."[xvii]

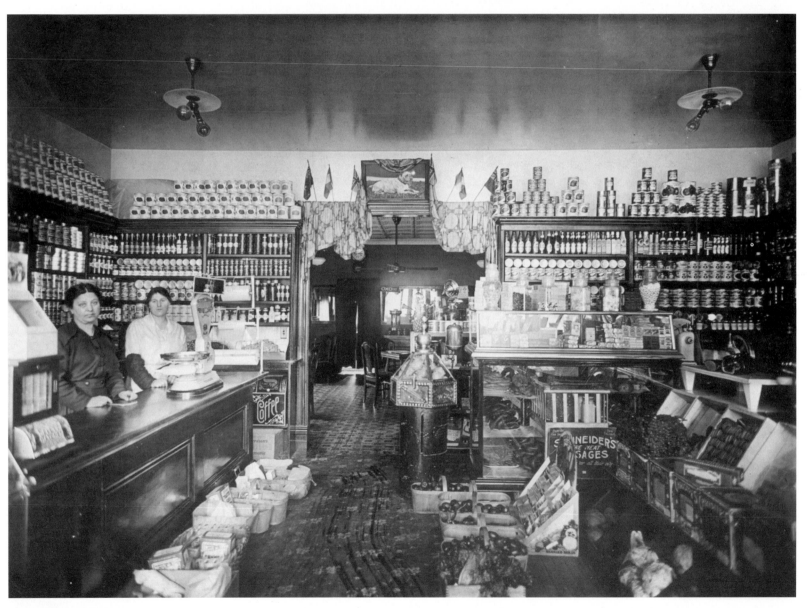

Henning's Grocery Store, Preston.
M.A. Van Sickle Collection

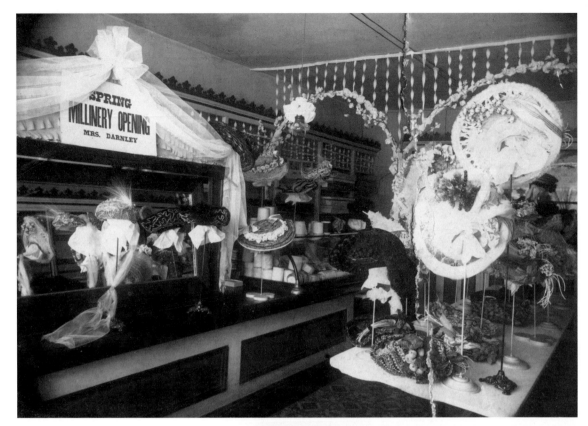

Mrs. Darnley's Millinery, Preston.
S.K. Walker Collection

Fischer Meat Market, Waterloo. Notice the sawdust on the floor, a common practice in meat and fish shops.
Local History Department, Waterloo Public Library

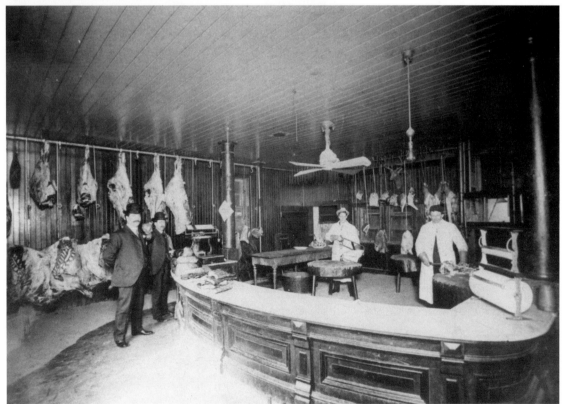

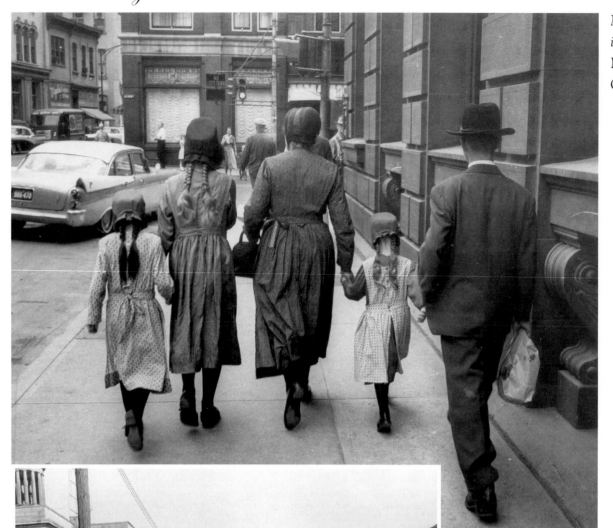

Mennonites walking on Queen Street in downtown Kitchener, circa 1960. Mennonite Archives of Ontario at Conrad Grebel University College

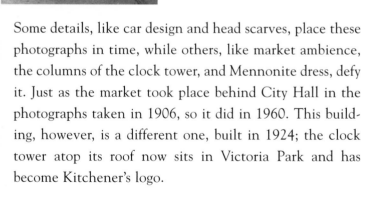

Some details, like car design and head scarves, place these photographs in time, while others, like market ambience, the columns of the clock tower, and Mennonite dress, defy it. Just as the market took place behind City Hall in the photographs taken in 1906, so it did in 1960. This building, however, is a different one, built in 1924; the clock tower atop its roof now sits in Victoria Park and has become Kitchener's logo.

Kitchener Market, behind a former City Hall, circa 1960. Bob Bomberg/Mennonite Archives of Ontario at Conrad Grebel University College

10
What's To Do?

Conditions in Waterloo County encouraged industry. There was plenty of water power, and when steam became an alternative source of energy, immigrants with vital skills were attracted to the area by its European culture. The demand for goods was widespread, the advent of railways meant transportation was no longer an issue, and the mature economies of Britain and the United States pointed toward manufacturing as an area of growth. Commentators describing Waterloo County's advantages chose particular words to describe its citizens — persevering, determined, hard-working, enterprising — and there was also a pervasive spirit of co-operation.

Once the manufacturing spirit had taken hold, the range of products was wide. The goods that could be shipped out, according to the Grand River Railway in 1939, suggest a high level of activity. From Hespeler, there was furniture, stoves and furnaces, tool handles and hockey sticks, washing machines, stamped and enamelled ware, and woollen goods from one of the largest textile mills in Canada. In Preston, children's wagons and electrical fittings stand out, along with office, bank, and church furnishings. Galt created large boilers, stationary engines, and heating and ventilating equipment. Kitchener was notable for furniture, rubber goods, and tanning, as well as confectionery and beverages. Waterloo, unique as an insurance centre and the home of J.E. Seagram & Sons, one of the oldest and largest distilleries in Canada, also produced furniture, barrels and kegs, shoes, and mattresses.[xviii]

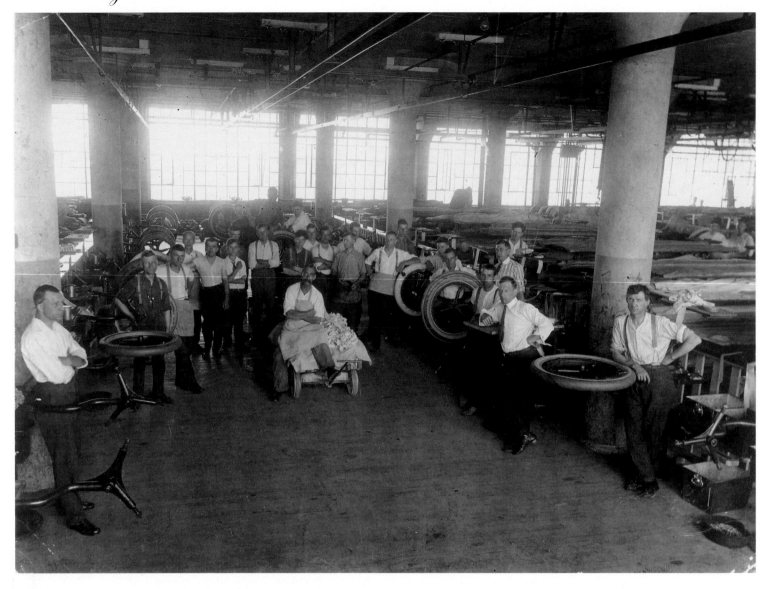

Tire finishing room at Dominion Tire, Kitchener, 1918.
Denton/Region of Waterloo, Doon Heritage Crossroads

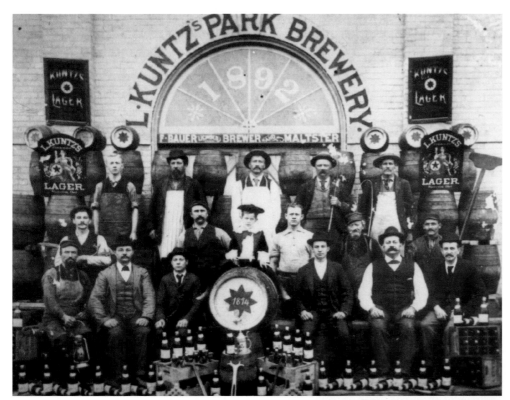

Kuntz Park Brewery workers, Waterloo, 1894. Kitchener-Waterloo *Record* Photographic Negative Collection, Dana Porter Library, University of Waterloo, Waterloo, Ontario N2L 3G1

Labour Day Parade, 1895. The Snyder Roos & Company parade entry in front of their own establishment.
Local History Department, Waterloo Public Library

Each company has a story, each town has a compendium of manufacturing heroes. The Kuntz Brewery is an example. Employees, photographed in 1894 with the paraphernalia of their craft, worked for a company started in Waterloo by David Kuntz, a cooper and brewer who came from Wiesbaden, Germany in the 1830s. Kuntz family members continued the business until 1929, when Canadian Breweries became involved. Two small park squares on either side of King Street at William, established in the Kuntz era as civic beautification projects, still distinguish the entrance to the city's downtown area. In the early 1900s, a three-tiered fountain with a small iron railing around its base was added to the square on the west side and became a favourite wading pool for children on hot summer days. The square on the east side of King Street had been the site of the original Waterloo farmers' market.

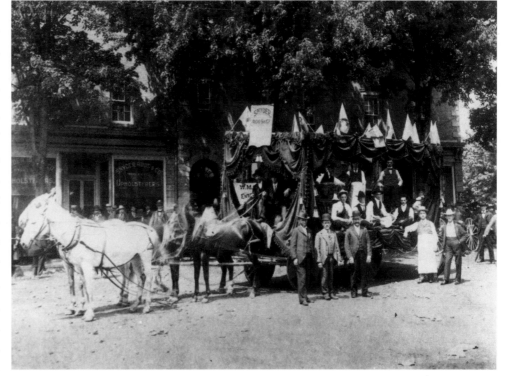

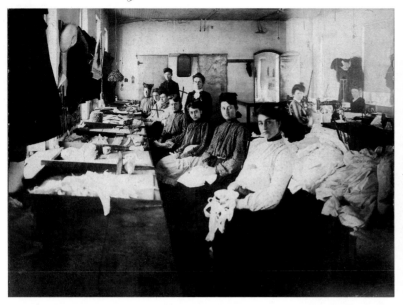

Wiegand's Shirt Factory, Berlin, circa 1900.
Region of Waterloo, Doon Heritage Crossroads

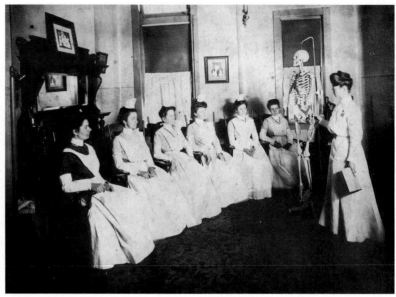

Hospital nurses with instructor and model, Berlin, 1904–1905.
Waterloo Historical Society

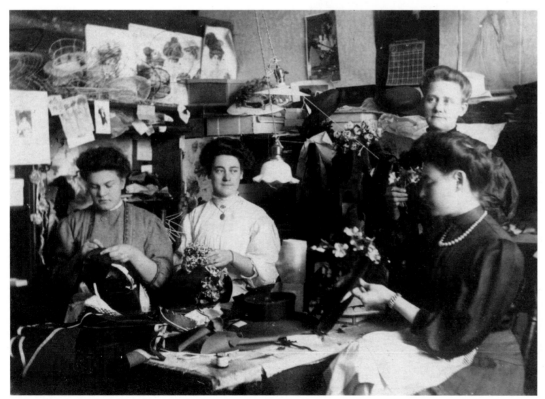

The workroom at Sarah Jane Darnley's hat shop, Preston.
S.K. Walker Collection

In this climate of enterprise, there was much to be done, and both men and women were at work. Women with jobs in the textile industry might work in factories, or in workshops, like this milliner's, or they might do piecework at home.

Few of these photos are candid or snapped. Instead, the workers have deliberately paused in the middle of their tasks. When the camera is gone, we assume they will simply pick up their tasks where they left off. Now, with faster film, they would not have to stop at all; indeed, we might expect them to carry on for us to get a clear sense of what they do. Consequently, their gaze, when it is direct, is unexpected.

In the kitchen at 82 Dorset Street, Waterloo. This photograph is a rare example of domestic work in local archival collections.
Local History Department, Waterloo Public Library

The ice house, Blair, circa 1945. The structure seen here, destroyed by fire in 1955, was originally a woollen mill built in 1808 to take advantage of one of the village's two creeks. At the time of this photograph, it was used to store ice from the mill's dam for use in domestic ice boxes. Since the ice surface also functioned as the local skating rink, the arrival of the saws in late winter necessarily marked the end of the hockey season.
S.K. Walker Collection

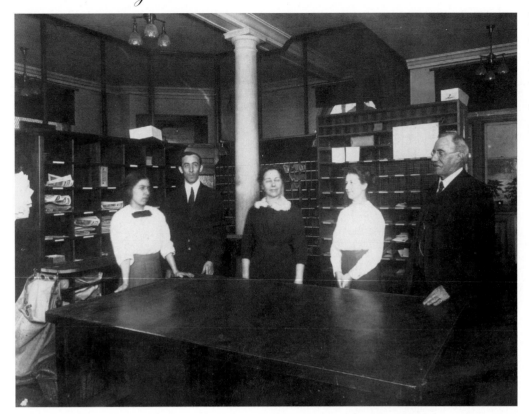

In addition to turning the wheels of industry, workers were needed to improve and maintain public institutions. Though the staff in these two photographs have the demeanor of another era, the institutions they worked for continue in much the same fashion today.

Waterloo Post Office Staff, 1912–1913. Local History Department, Waterloo Public Library

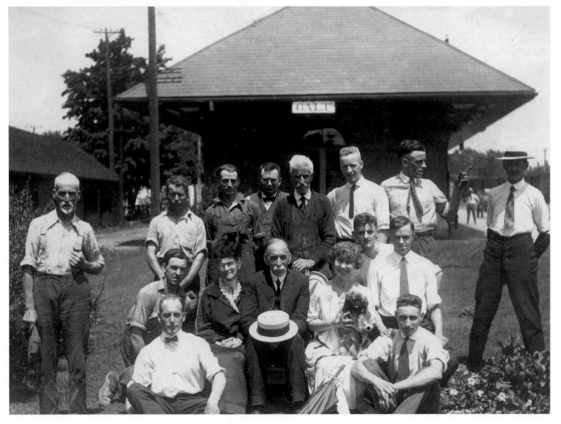

CNR Station staff, Galt, circa 1940. S.K. Walker Collection

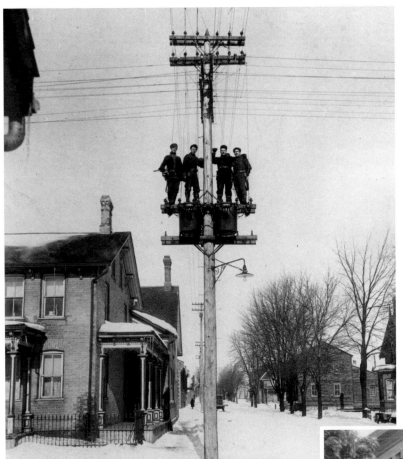

The Squirrel Gang, Waterloo, 1912. The spirit of the Squirrel Gang — acrobatic hydro linesman in Waterloo with something of a public profile — was captured by an unknown photographer in 1912. The image breaks out of the usual posed mode even though there wasn't much room for the men to manouevre on the crossbar of their pole.

Hydro One Inc., Archives/ Neg. no. HP-1110/Local History Department, Waterloo Public Library

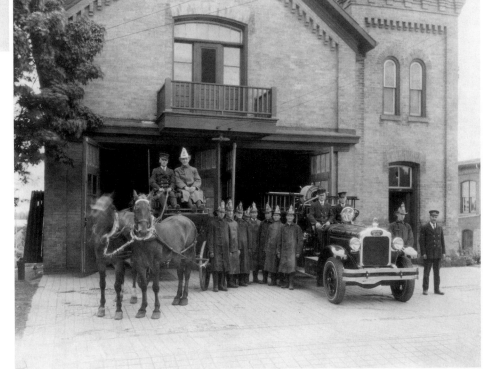

Waterloo Fire Department, circa 1928. Firefighters fall into a category of their own. The daring and courage associated with their work, combined with the uniforms and equipment, guarantee them a place in local histories. Photographs like this are often accompanied by an account of the department's history, from a volunteer brigade (working against the odds just to get enough water to the fires) to the professional organization we know. In 1928, when this department purchased its first motor hook and ladder truck, the days of horse-drawn equipment were numbered.

Local History Department, Waterloo Public Library

11
The Wars

Before the Great Wars of the twentieth century, which found Britain and Germany on opposing sides, German culture was strong in Europe and flourishing in Waterloo County.

Friedensfest, a peace festival in our Berlin on May 2, 1871, marked the end of the Franco-Prussian war with a joyous celebration. From dawn until well into the night, crowds in Berlin and Waterloo gathered for church services, parades, singing, and fireworks. Here, at the County Court House, a German oak was planted as a symbol of the occasion.

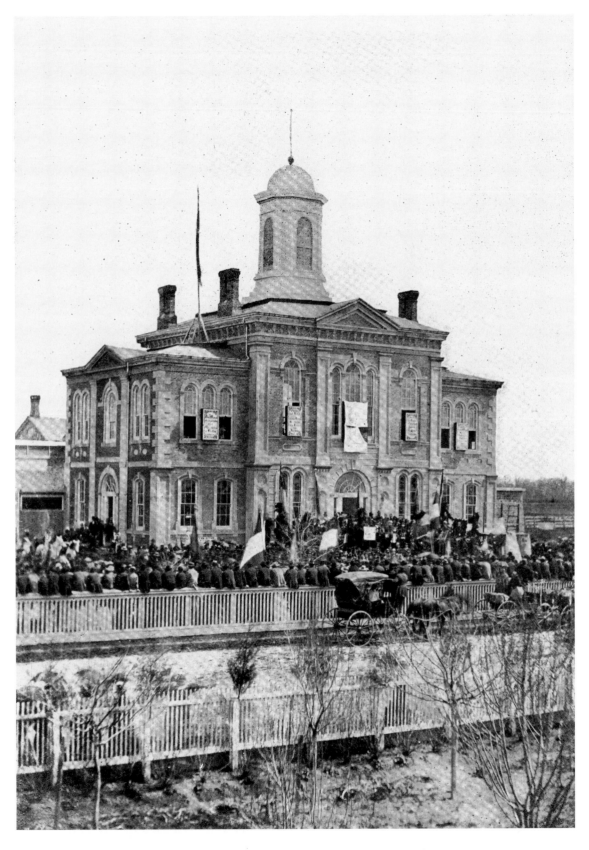

Friedensfest, Berlin, 1871. This version of the original 1871 photograph appeared in *Berlin Today*, a 1906 publication commemorating the city's heritage.

Toronto Public Library

That German culture had firm roots in Waterloo County was clearly expressed once again when a Peace Memorial was unveiled in Berlin's Victoria Park in the summer of 1897. A bust of Kaiser Wilhelm I was not out of place in Britain's Dominion of Canada.

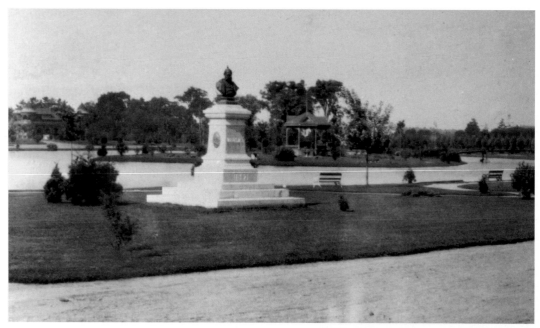

The Peace Memorial with the Kaiser's bust, Victoria Park, Berlin, 1898.
The *Record* Historical Collection, University of Waterloo

The Kaiser's bust being retrieved from the lake in Victoria Park, August 23, 1914.
Ernest Denton/The *Record* Historical Collection, University of Waterloo

The decades of peace and good relations in the city were not enough, however, to calm the tensions that arose in Berlin when the First World War broke out. One of the casualties was the Kaiser's bust. Late on a Saturday night in August 1914, three young men pulled the bust from its pedestal and threw it into the lake. The youths were quickly apprehended, and the bust, once retrieved, was safely stored away. The subsequent history of the bust remains a puzzle: it reappeared briefly in 1916, then vanished altogether. Another loss in 1916, and one that caused considerable dissension, was the city's name. Berlin became Kitchener, named for a popular British military leader; a bold sign of the county's German heritage was relinquished in favour of solidarity in time of war.

These images of the First World War show troops preparing to leave for overseas in 1916. By that time, it had become clear that conditions in the trenches of Europe were intolerable. What had been an eagerness to volunteer was giving way to the necessity of recruitment. With the hindsight that can accompany old photographs, each of these carries a measure of poignancy.

In March, silhouetted against the snowy streets, soldiers of the South Waterloo 111th Battalion paraded in New Hamburg; in finer weather that same year, small boys watched troops drilling in Victoria Park. Occasions like these roused spirits and strengthened morale.

Troops of the 111th Battalion, New Hamburg, 1916.
Heritage Wilmot

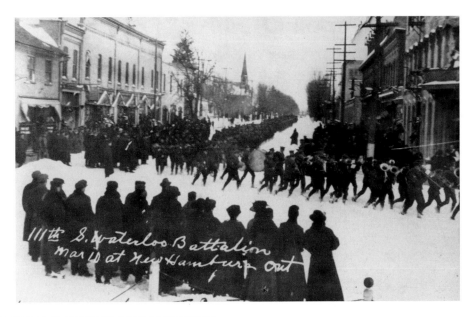

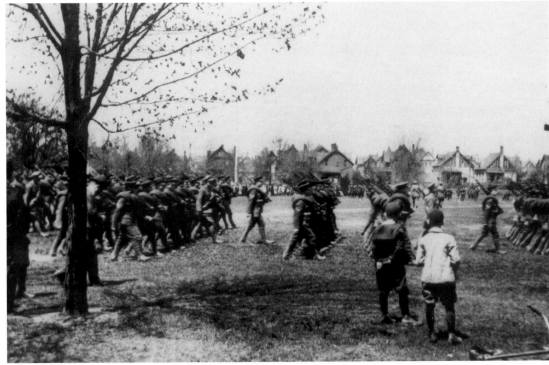

Soldiers drilling in Victoria Park, Berlin, 1916.
Breithaupt Hewetson Clark Collection, University of Waterloo

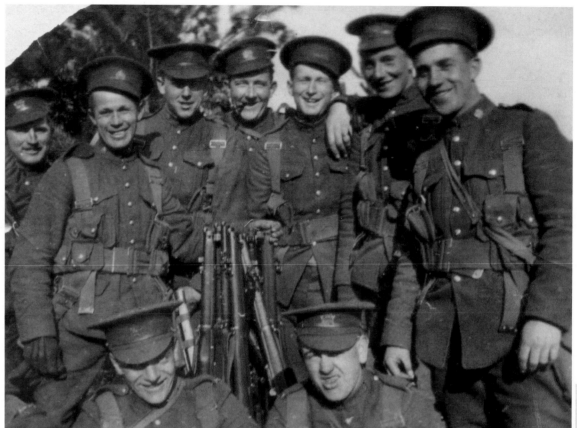

In the faces of Corporal Luft and his friends, preserved on a tiny and tattered photo, smiles of camaraderie cross a century; we know they left for Europe with brave hearts, certainly with ready smiles. Not so reassuring, perhaps, is the exquisitely composed image of the 118th Battalion at the train station leaving for London. A medley of shapes hides the soldiers from the camera at their departure.

Soldiers of the 118th Battalion; Corporal Fred Christian Luft, in the back row with the cigar. Berlin, 1916–1919.
Kitchener Public Library

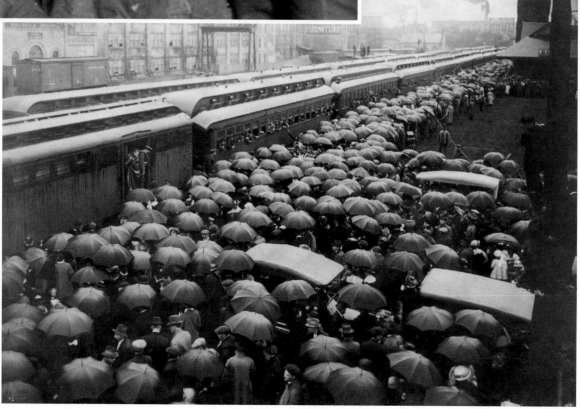

Soldiers of the 118th Battalion leaving for London. Berlin, 1916.
Waterloo Historical Society

As would be expected, a wider variety of photographs has been archived for the Second World War. A series exists of the Women's Royal Canadian Naval Service recruits (WRENS), who trained in Galt at an officially commissioned facility called HMCS *Conestoga*; another set of striking images, done by Elliot Law, showed men training at the Galt Aircraft School for work in the Royal Canadian Air Force. Photographs of the non-military aspects of the war effort include images of women working at Dominion Woollens in Hespeler and men building roads in Montreal River as alternative service.

Men of the Highland Light Infantry, headquartered in Galt, were sent overseas in 1940. The Scots Fusiliers, a Kitchener-Waterloo militia regiment, "rebatched" as Highland Light Infantry and went as well. According to the website of the Highland Fusiliers, an amalgam of the two regiments created in 1965, "The HLI of C has the distinction of being the only Regiment in the British Commonwealth that had no man taken prisoner, no man posted missing and no ground once taken was ever given up."

Highland Light Infantry, November 1940.
Kitchener-Waterloo *Record* Photographic Negative Collection, Dana Porter Library, University of Waterloo, Waterloo, Ontario N2L 3G1

Scots Fusiliers at the train station, 1940.
Kitchener-Waterloo *Record* Photographic Negative Collection, Dana Porter Library, University of Waterloo, Waterloo, Ontario N2L 3G1

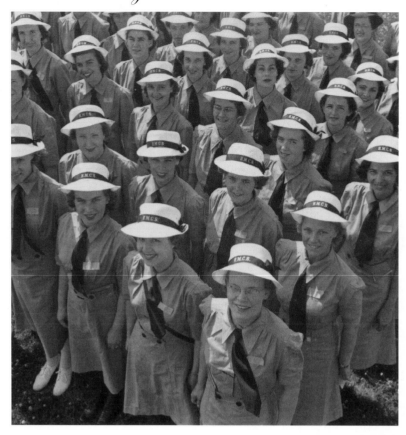

New entry of Women's Royal Canadian Naval Service aboard HMCS Conestoga, Galt, 1943.

Glen M. Frankfurter/National Archives of Canada/PA-144268

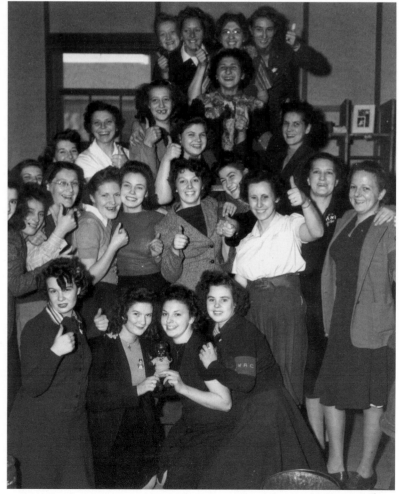

Canadian Women's Army Corps recruits, Waterloo.

Kitchener-Waterloo *Record*/Local History Department, Waterloo Public Library

Women at work for the cause in industrial settings offered the dramatic compositional opportunities exemplified in these photographs taken at two of the county's companies. Dominion Woollens in Hespeler recruited women from other provinces to manufacture cloth for the military; Sunshine Waterloo, a company that had been manufacturing farm equipment and bicycles, turned to other items during the war, like swivel seats for Lewis guns and noses for smoke bombs.

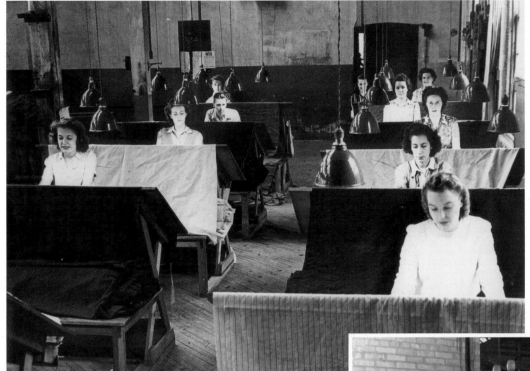

Women working on lengths of fabric at Dominion Woollens in Hespeler.
Waterloo Historical Society

Women welding the noses of the 2-inch M.L. Smoke bombs,
Sunshine Waterloo Co., 1943.
Local History Department, Waterloo Public Library

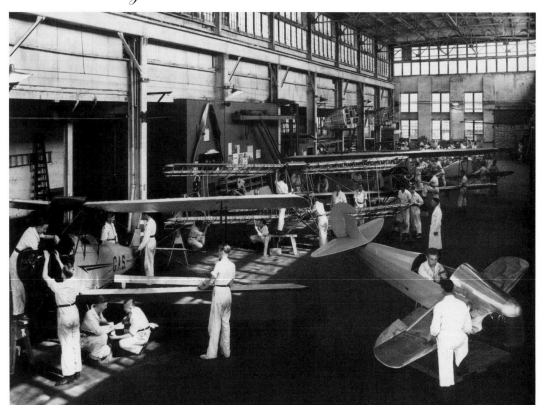

Galt Aircraft School.
Elliot Law/Law Photography, Galt

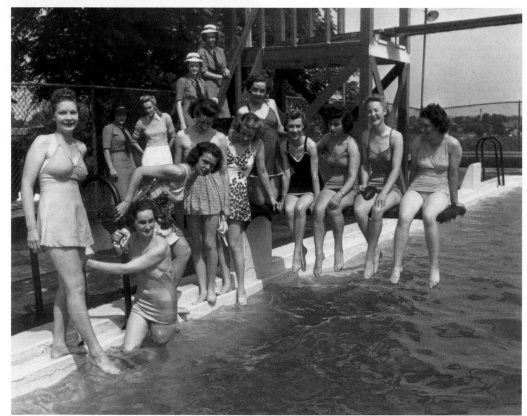

Members of the Women's Royal Canadian Naval Service swimming at the Preston pool, July 1943.
Gerald Thomas Richardson/National Archives of Canada/PA-156458

Victory Loans were the government's way of encouraging Canadians to help finance the war effort during both World Wars. Parades like these, along with posters and patriotic slogans, boosted morale and raised money during the Second World War. Notice how St. John's Lutheran Church, which would be destroyed by fire in 1959, gives definition to the slight rise on King Street North in Waterloo.

Victory Loans Parade, Galt.
S.K. Walker Collection

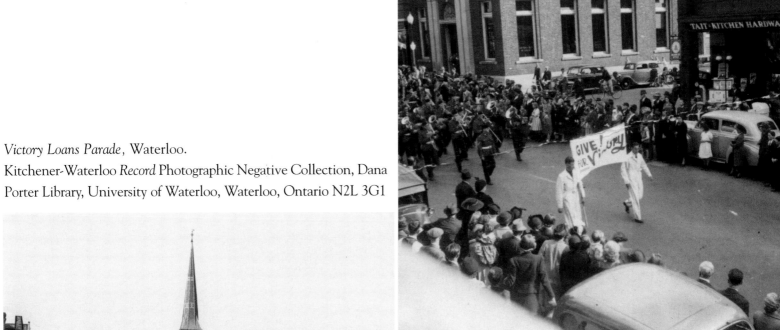

Victory Loans Parade, Waterloo.
Kitchener-Waterloo *Record* Photographic Negative Collection, Dana Porter Library, University of Waterloo, Waterloo, Ontario N2L 3G1

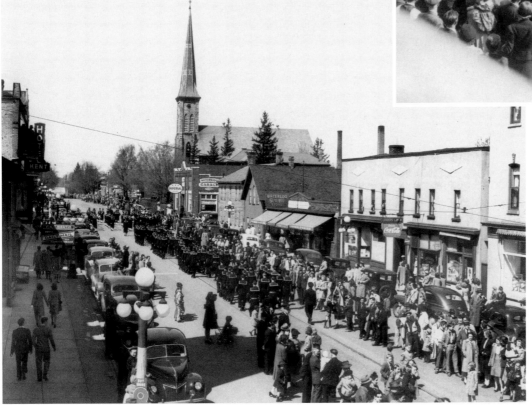

Mennonites from Waterloo, along with other peace churches, negotiated with officials in Ottawa to find alternative, non-military ways for conscientious objectors to serve during the war. By 1941, a work camp was set up at Montreal River, a short distance north and west of Sault Sainte Marie. The task was road-building — to continue the Trans-Canada Highway — and the men's days, from eight to five, were spent "moving gravel, clearing land, aiding surveyors, blasting, grading, and digging, digging, digging."[xix] Hymn-singing was a part of their religious life during the remaining hours.

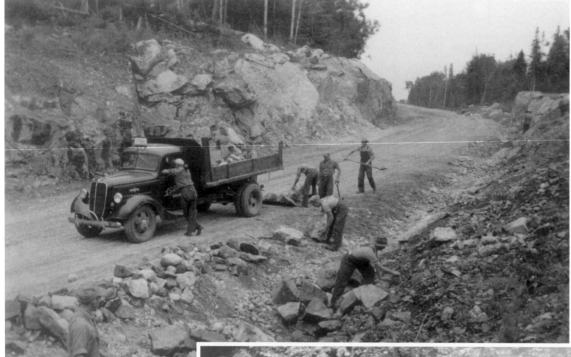

Road-building at Montreal River during World War II.
Clayton Burkholder's photo album, Mennonite Archives of Ontario at Conrad Grebel University College

Hymn-singing around a campfire at Montreal River.
Clayton Burkholder's photo album, Mennonite Archives of Ontario at Conrad Grebel University College

Stockings of any kind were hard to find during the war, since both silk and nylon were needed in the war effort. Nylon stockings, which first appeared at the New York Fair in 1938, did not replace silk until after the war. Signs like this indicate the demand had been created but not yet met.

Sorry! No Nylons, 1946.
Waterloo Historical Society

Displaced Persons, individuals whose lives in their own countries had been disrupted by the war, came to Canada when the war ended to begin their lives anew. While it is difficult to sort those arriving on the platform from those there to welcome them, the hopes and fears of newcomers are emotions that most Canadians understand and appreciate.

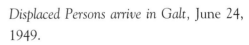

Displaced Persons arrive in Galt, June 24, 1949.
Kitchener-Waterloo *Record* Photographic Negative Collection, Dana Porter Library, University of Waterloo, Waterloo, Ontario N2L 3G1

12

Just This Once...

If, as objects, photographs fix moments in time, then by definition, any photograph will have happened "just this once." Even so, some photographs record pivotal moments more boldly than others.

The photograph taken on May 13, 1857, likely by George Esson, when citizens gathered to lay the cornerstone for Galt's Town Hall, is of interest on several counts. Pockets of blurring, where movement has eluded the camera's process, indicate an early stage in photographic technology. So too does the composition of the image. For such an important event, the principal action remains hidden from our view. The idea that the event might be photographed for posterity, and so some individuals should step aside for the photographer, has not yet seized the public's imagination.

Also, since the Town Hall about to be built has remained central to civic life up to the present, the site is familiar — and yet the buildings on it are not. What is visible now has not yet come into being. That layers of time might adhere to a particular place, if only because the camera gives us evidence that they do, does not trouble us visually, however awkward the concept might be.

Laying the cornerstone for the Galt Town Hall, May 13, 1857.
George Esson?/Law Photography, Galt

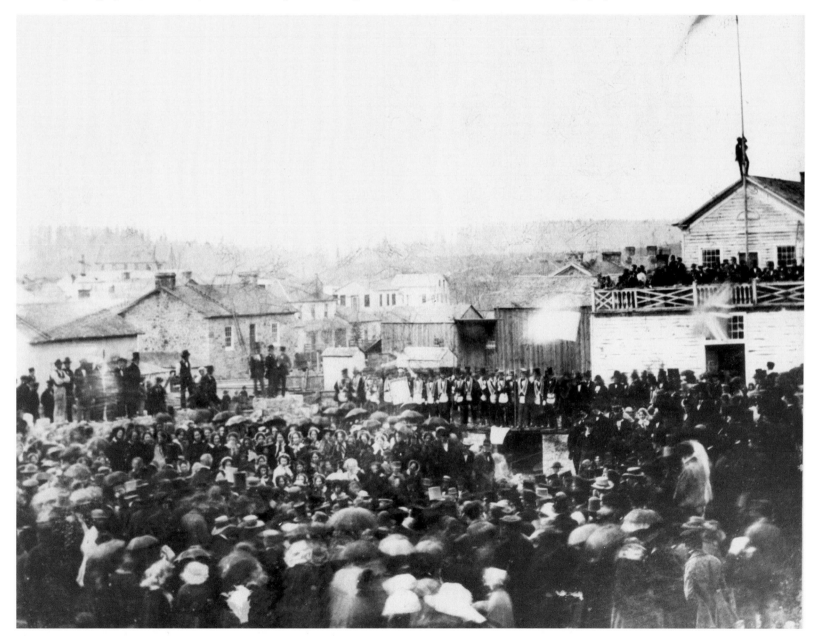

Fires have devastating consequences on the shape of urban landscapes. Good may follow, but only as another day's enterprise. Both of these fires occurred in 1906 and consumed the buildings they struck. On the twenty-sixth of August, the photographer reached the fire at the Canada Furniture Company on King Street South in Waterloo while it still burned. All is not well: the firemen, in silhouette beside the large fire hose reels, keep a safe distance; thick smoke billows toward them; and the fire hose points toward the ground.

"One of the most destructive fires in the history of Waterloo County," according to the local *Daily Telegraph*, broke out in the Preston street railway car barns in the middle of a December night. Nearby residents "described the appearance of the flaming building, mingled with the snapping of electric wires and the blue coloured lights which resulted therefrom as a sight which was grandly great and beautiful to behold."[xx] The daylight photograph shows the results. Almost all the rolling stock was destroyed, but quick negotiations with nearby cities meant that regular service was scarcely interrupted.

Canada Furniture Company fire, Waterloo. August 26, 1906.
Local History Department, Waterloo Public Library

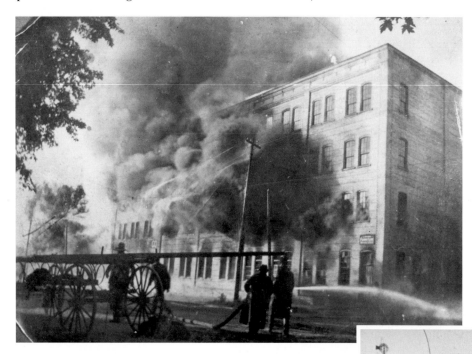

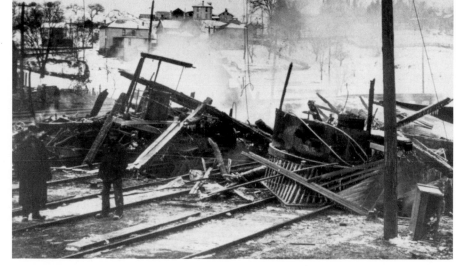

G.P. & H. and P.& B. Street Railway Co. car barn fire, Preston, December 4, 1906.
William Schaefer/William Clack Collection

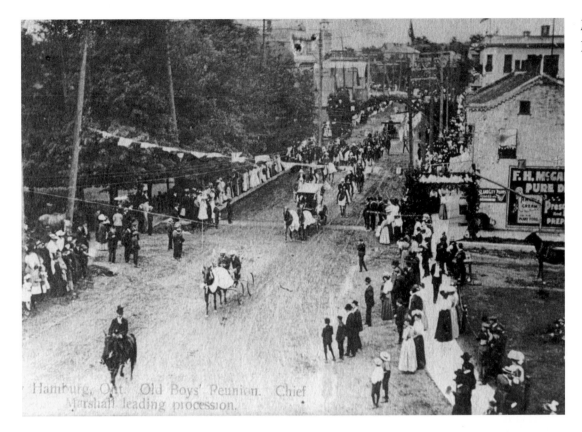

New Hamburg Old Boys Reunion, 1907.
Heritage Wilmot

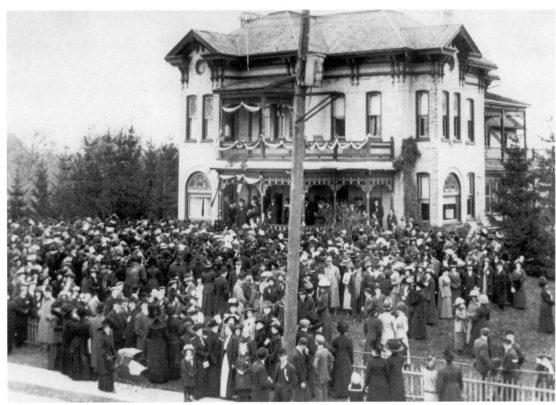

Official opening of Waterloo Lutheran Seminary, October 30, 1911.
Local History Department, Waterloo Public Library

From Louis Jacob Breithaupt's diaries. Monday, July 15: "'Cityhood Celebration' commenced in Berlin this evening and is to continue during the week. Aeroplane ascension — the first in Berlin." Tuesday, July 16: "Many strangers in the new city." Wednesday, July 17: "Civic Holiday. Immense crowds. Speeches at City Hall. Mayor Schmaltz, Hon. Adam Beck and others. Many bands attending. Deputations from most prominent towns & cities in Western Ont. present. Civic luncheon pm at the Grand River Club House. Attended. Fireworks and tattoo. Grand weather."[xxi]

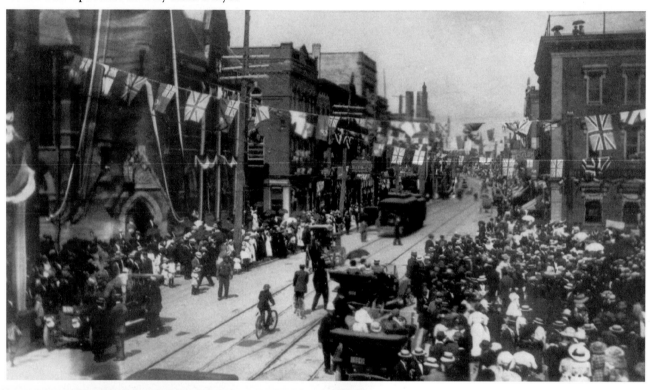

Celebration of Berlin Cityhood, July 15–20, 1912.
Breithaupt Hewetson Clark Collection, University of Waterloo

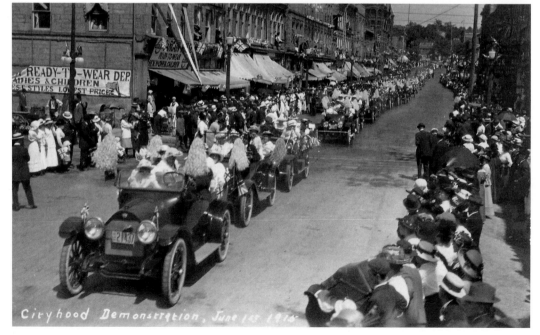

Celebration of Galt Cityhood, June 1, 1915.
Region of Waterloo, Doon Heritage Crossroads

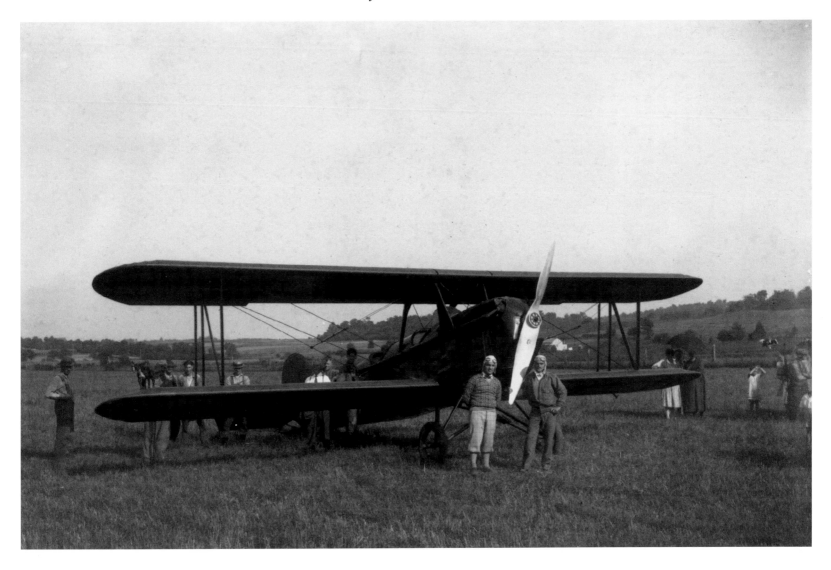

First plane lands in New Dundee, August 27, 1928.
Herman Kavelman / Heritage Wilmot

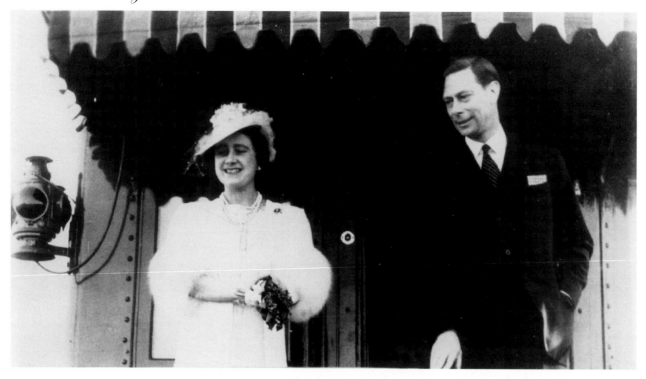

Visit of King George VI and Queen Elizabeth,
Kitchener CNR station, June 6, 1939.
Kitchener Public Library

Waiting for the Royal Train, same
day.
M.A. Van Sickle Collection

"A photograph is an event transformed into an object. Rather than being a record of *things*, as we often suppose, it is a fixing of light in space over *time*."[xxii] — Shelley Rice

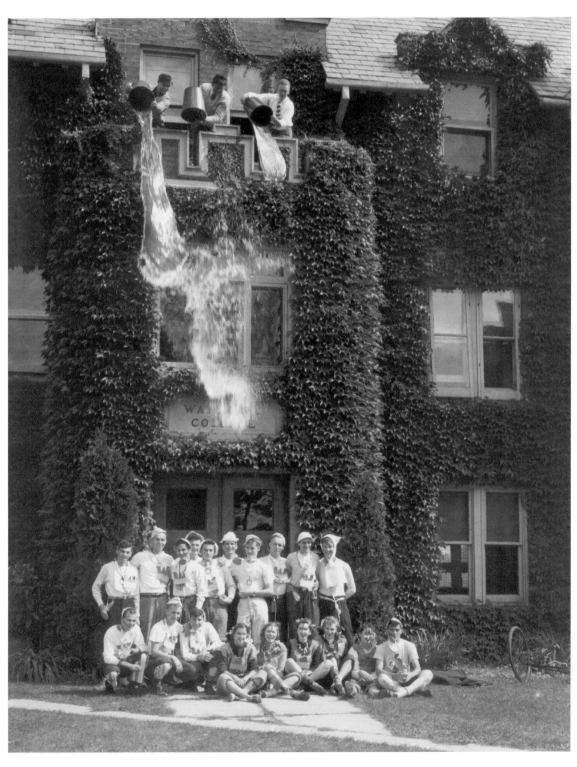

Waterloo College initiation, 1947.
Waterloo Historical Society

13

Again and Again

"In August 1883, there was a terrible flood on the Nith River. Some of Jacob Siegner's cattle were on an island in the middle of the water. He went down, with a pail of salt, and tried to coax them to swim over to him but they refused. However, the river became so high that the island disappeared, and the cattle were forced to swim downstream. They had to duck their heads to get under the bridge but finally reached land and were saved. This flood took away all the line fences, snake fences which zigzagged across the river, and all the bridges from Kingwood to New Hamburg. So Jacob Siegner decided to buy the west half of Lot 2, Concession 3, from Charles Robertson, just so he wouldn't have to replace the fences."[xxiii]

— Interview with Abe Siegner, 1982.

The water inundating the village of Ayr had already passed through Jacob Siegner's farm. In its journey through Waterloo County, the Nith River touches Wellesley Township, then goes south through Wilmot Township and into Oxford County; it crosses back into Waterloo County's North Dumfries Township near Ayr for a short and winding journey before going on to join the Grand River south of the county near Paris.

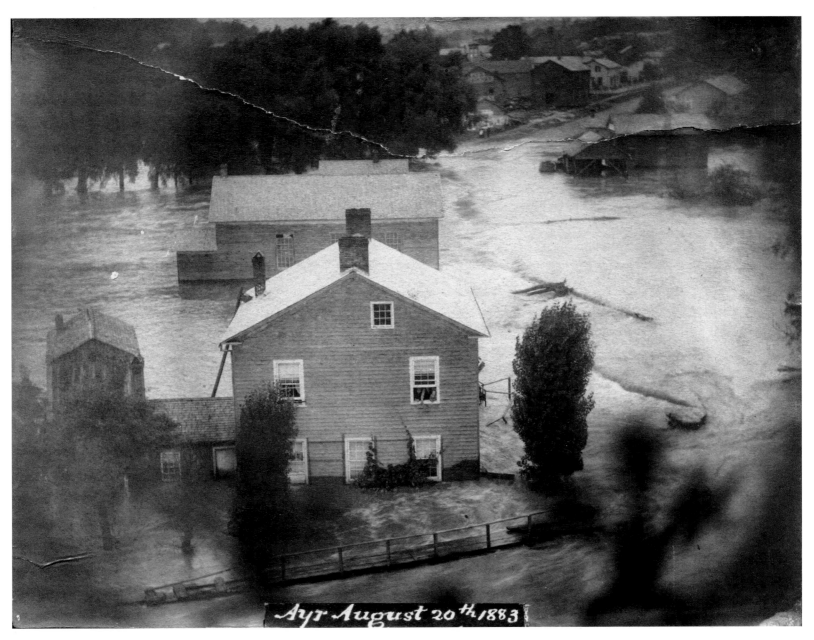

Nith River flood, Ayr, August 20, 1883.
Waterloo Historical Society

At one time, snow melt, spring rains, and dry summers set natural rhythms in the Grand Valley. The woody swamplands in the northern reaches of the river absorbed excess water in the spring, then released that water over the dry summer months when the river was low. With settlement came logging, and over time that activity decreased the river's capacity to regulate itself; in the 1860s, logging was particularly intensive and damaging. As the population grew, the damage caused by spring floods and the consequences of inadequate water supplies in the summer became increasingly serious problems.

Once the flow of the river influenced hydroelectric production as well as the quality of drinking water and the efficiency of waste disposal, unpredictable conditions became intolerable. A tremendously harmful flood in 1930 set committees to work, and in 1942, the Shand Dam, north of Fergus, became the first of several dams built over the next three decades to regulate the flow of the river.

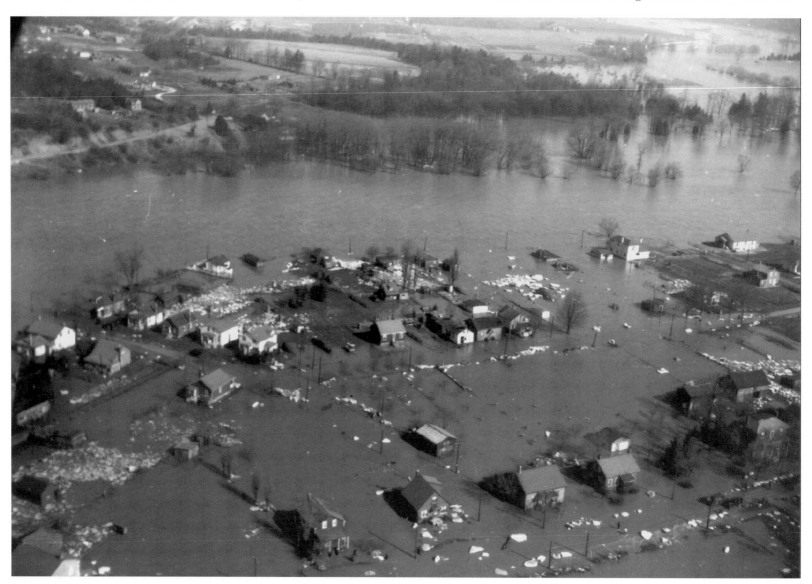

Grand River flood, Bridgeport, 1948.
Kitchener-Waterloo *Record* Photographic Negative Collection, Dana Porter Library, University of Waterloo, Waterloo, Ontario N2L 3G1

Scenes of flooding, like these at Main and Water Streets in Galt in 1929, were repeated fairly frequently. Fire, another natural hazard that plagued early towns, had destroyed many of the original frame structures on Main Street in the 1850s. The stone buildings that replaced them, designed to prevent similar disasters, remain a distinctive feature of the city.

In Blair, as I recall, flooding seemed natural enough and could do little damage to a village set high above the river. Finding photographs of derailed trains in nearby lower lying areas, tipped over amidst huge chunks of ice, has changed my mind, though I saw nothing of that myself. Instead, I remember watching the powerful and muddy river slowly spread across "the flats," covering everything until the hills begin to rise on the other side of the valley. And I remember looking down over the railing of the old iron bridge — which shook wildly when cars drove across it — to marvel as the force of the water hit the stone piers, sometimes pushing large chunks of ice along with it. These memories come forward so easily I suspect the elemental power of the river seeps into local imaginations, and stays.

Main Street, Galt, 1929.
Norman Wildman/S.K. Walker Collection

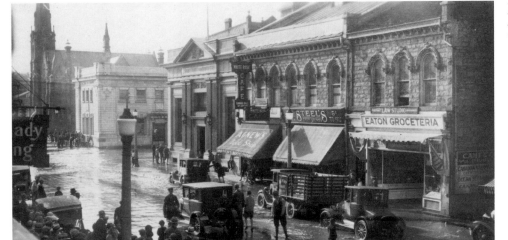

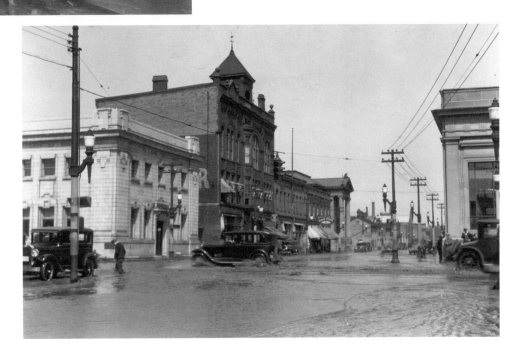

Water Street at Main Street, Galt, 1929.
S.K. Walker Collection

The L.E. & N. railway tracks are buried under the ice piled high on Water Street. Shortly after this photograph was taken, a crew of men began the work of clearing them.

Water Street South, looking north, Galt, February 1930.
S.K. Walker Collection

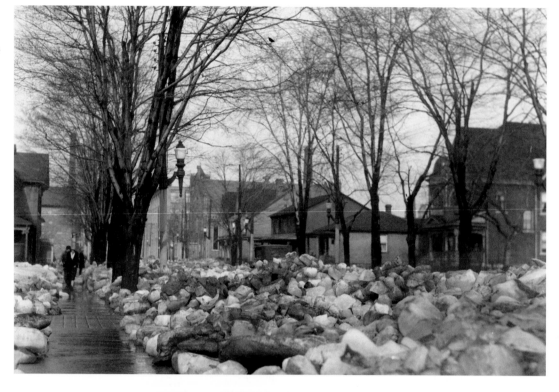

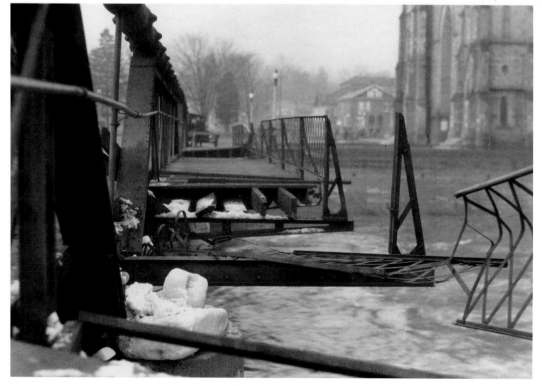

The consequences of this damaging flood in 1930 precipitated action that led to management of the river by the Grand River Conservation Authority.

Main Street Bridge, Galt, February 1930.
Norman Wildman/S.K. Walker Collection

14

Gathering Together

Communities gather to face adversity, to find social pleasure, and to work efficiently. The bee has long been a feature of rural life in Ontario: neighbours and families gather together to accomplish tasks that are onerous without help and more effectively done with the differing skills of many hands. Often bees have been organized around seasonal work. Some tasks that were important in the early settlement period became less necessary, like logging and stump-pulling. Other efforts have a longer history as group work, for example ploughing and threshing, butchering, quilting, and apple-paring. Barn-raisings are perhaps the most dramatic feats of sharing.

As much as they were opportunities to get work done, bees were also social events, with plenty of good food. In some communities, dancing figured in the festivities, as did whisky — with a number of distilleries operating in the county, it could be cheap and plentiful.

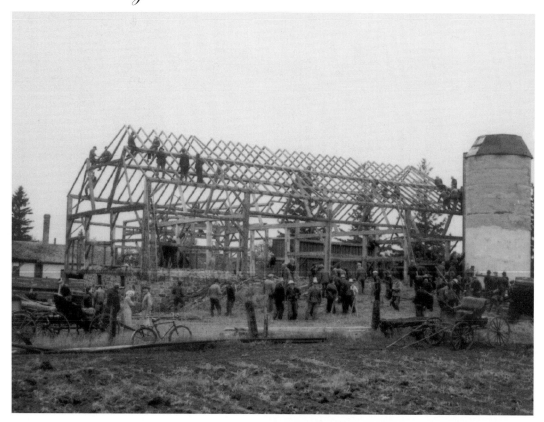

Barn-lowering on the Elmira highway, 1946.
Kitchener-Waterloo *Record* Photographic
Negative Collection, Dana Porter Library,
University of Waterloo, Waterloo, Ontario
N2L 3G1

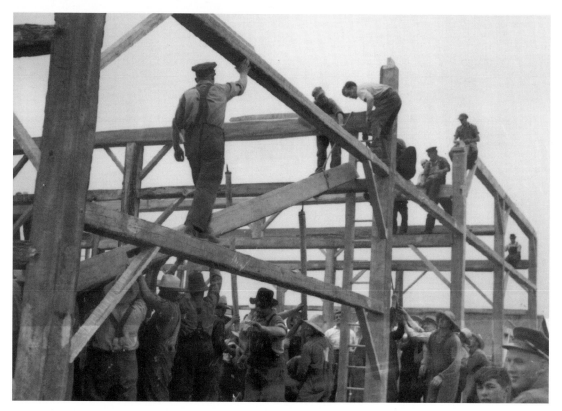

Barn-raising in St. Agatha, 1947
Kitchener-Waterloo *Record* Photographic
Negative Collection, Dana Porter Library,
University of Waterloo, Waterloo, Ontario
N2L 3G1

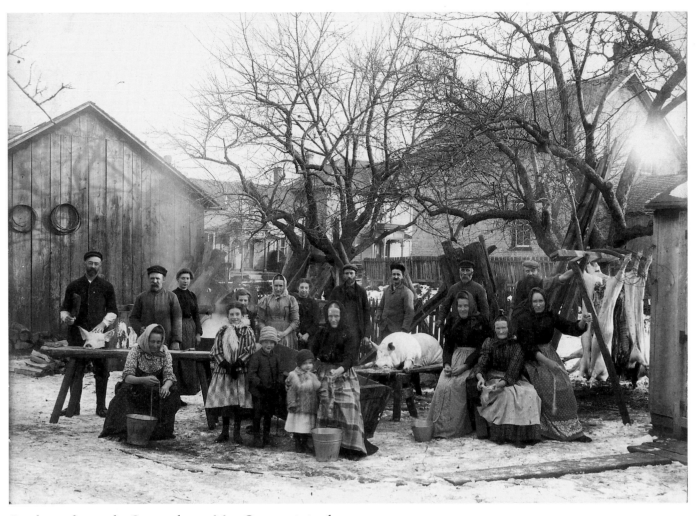

Butchering bee at the Ottman home; Mrs. Ottman is in the
centre with the little girl. Wellesley, circa 1900.
Region of Waterloo, Doon Heritage Crossroads

The relaxed energy of a schnitzing bee and the satisfaction of sorting goods for shipment overseas are among the rewards of gathering together with common purpose.

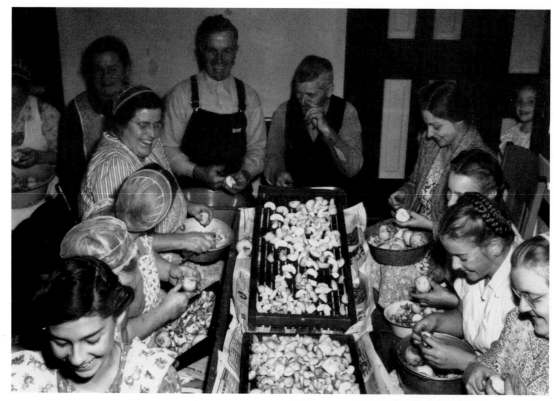

Schnitzing (apple-paring) bee, Pine Hill, 1947.
Kitchener-Waterloo *Record* Photographic Negative Collectio, Dana Porter Library, University of Waterloo, Waterloo, Ontario N2L 3G1

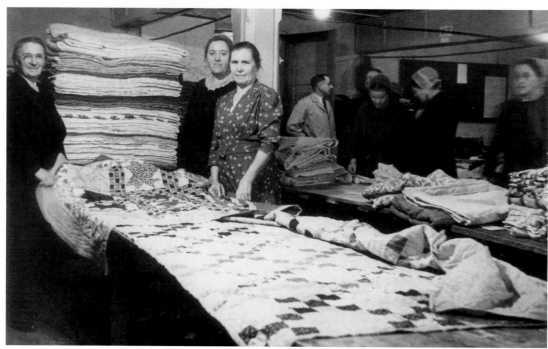

Preparing quilts for shipment overseas, First Mennonite Church, Kitchener, 1950s. Mennonite Archives of Ontario at Conrad Grebel University College

At local fall fairs, usually lasting a few days, farm families in Waterloo County have been able to show their animals and produce in competition and assess new farming methods. Over the long term, the fairs have played an important role in improving farming techniques. For the urban crowd, horse shows have been a continuing attraction. For everyone, the fall fair signalled the annual visit of the carnival, with games of chance and midway rides.

Galt Fall Fair, 1947
Kitchener-Waterloo *Record* Photographic Negative Collection, Dana Porter Library, University of Waterloo, Waterloo, Ontario N2L 3G1

New Hamburg Fall Fair, 1947
Kitchener-Waterloo *Record* Photographic Negative Collection, Dana Porter Library, University of Waterloo, Waterloo, Ontario N2L 3G1

15
Festivities: Saengerfest, Kirmess & Marching Bands

The German traditions we identify with Oktoberfest, including cultural events, general good cheer, and civic festivities, had earlier manifestations in Berlin's and Waterloo's Saengerfests ("song festivals") and in Preston's Kirmess. Both festivals, which lasted for several days, belong to the years between the Franco-Prussian War and the First World War, when Waterloo County took a great deal of pleasure in its German heritage.

In Berlin, a special arena went up on the edge of town for the Saengerfests, with a large stage for bands and choirs. Streets festooned with bunting and evergreen arches welcomed bands and merrymakers from cities of every size, including Montreal, Buffalo, and Listowel.

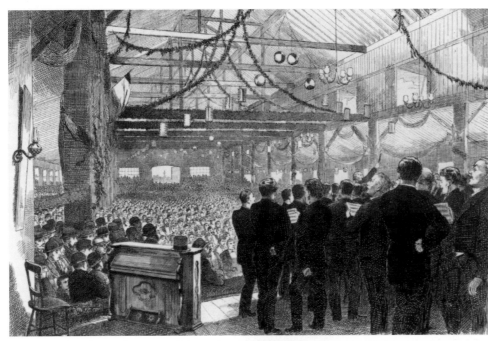

The concert hall during the Saengerfest, Berlin. Canadian Illustrated News, Vol. XII, September 4,1875, Page 153. Photo: From the National Library of Canada (www.imagescanada.ca)

Street decorations for Saengerfest, Waterloo, 1880s.
Local History Department, Waterloo Public Library

Preston's Kirmess had an international theme. Townsfolk dressed in the traditional garb of foreign nations paraded to an arena near Riverside Park; there, booths had been set up to sell assorted confectioneries, and vaudeville performances took place on stage. Some costumed Kirmess participants had their portraits done at Esson's studio.

Kirmess booths, Preston, circa 1912.
S.K. Walker Collection

Women in costume for the Kirmess, Preston.
S.K. Walker Collection

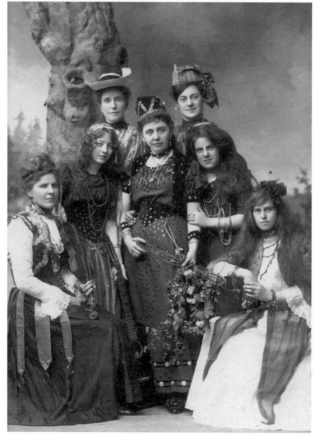

A portrait of Kirmess participants from Esson's Atelier, Preston.
S.K. Walker Collection

136

Bands, on parade or in concert, performed at both festivals and were popular at local events throughout the year. Kitchener, Waterloo, and several other towns in the county sustained active musical societies to ensure that tattoos and band festivals took place through much of the twentieth century.

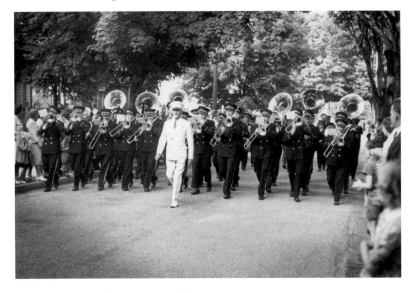

Waterloo Musical Society Band, 1947.
Local History Department, Waterloo Public Library

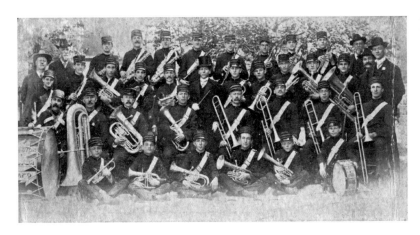

Preston Silver Band.
S.K. Walker Collection

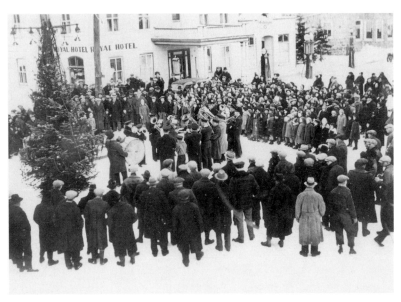

Christmas scene with the band playing, Wellesley Village, circa 1925.
Region of Waterloo, Doon Heritage Crossroads

16

The Pleasures of the Arts

In the last thirty years, attitudes toward the arts in Canada have altered in response to global cultural developments and to technologies that have changed how artists work. These photographs represent a very different era, when isolation was not uncommon, and establishing institutions to carry the arts forward required tremendous effort.

Two views of the value of the arts have played a major role in Canada's arts policies. One notion owes much to the nineteenth-century British attitude that art was a measure of the society that created it. A moral dimension threading through this philosophy made it clear that both the individual and the community would be immeasurably enhanced by the cultivation of the arts. The appeal of this view, that art does indeed lead to vibrant and strong communities, adds charm to the seriousness of these young performers.

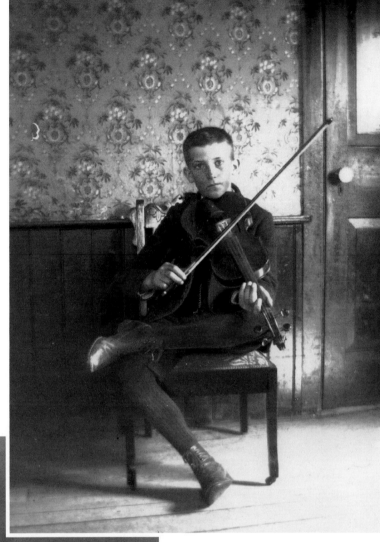

Miss Haskins's ballet class, Galt, circa 1940.
M.A. Van Sickle Collection

Boy with violin.
Herman Kavelman/Heritage Wilmot

The other view, articulated by Pierre Trudeau in 1969, held that the arts are "an essential grace in the life of a civilized people."[xxiv] Activities in the arts combine to create a richly satisfying life for the community. In Waterloo County, textiles illustrate the role the arts can play. Quilters, weavers, and needleworkers have been here from the early years of settlement, developing their techniques over time. The fashion show, with links to domestic practices as well as industrial and retail ones, illustrates how broad the reach of the arts can be.

YMCA *Fashion Show*, 1948.
Kitchener-Waterloo *Record* Photographic Negative Collection, Dana Porter Library, University of Waterloo, Waterloo, Ontario N2L 3G1

Susannah Brubacher Schmidt.
Mennonite Archives of Ontario at Conrad Grebel University College

Whatever contribution the arts make to a community, much pleasure comes from participation, practice, and performance.

A Galt production, probably Little Theatre, perhaps Schiller's *Mary Stuart*, circa 1940.
S.K. Walker Collection

Doon School of Fine Arts on location: painter Carl Schaefer with students, 1954.
Kitchener-Waterloo *Record* Photographic Negative Collection, Dana Porter Library, University of Waterloo, Waterloo, Ontario N2L 3G1

The institutions that support the arts, along with the humanities, are many. The Public Archives in Ottawa, which come to mind easily in the context of libraries, were established in 1872. Fifty years later, Sir Robert Borden, who had been the prime minister of Canada throughout the First World War, spoke with them in mind when he said, "Crops and manufactures do not make up the whole life of a nation. The development of the intellectual and spiritual qualities of the nation, of the moral qualities of the people, is surely not of less importance. A nation which neglects these higher considerations cannot hold its place in the world."[xxv]

Preston Public Library, circulation desk and collection, circa 1905.
S.K. Walker Collection

Preston Public Library, reading room, circa 1905.
S.K. Walker Collection

17
Parks & Good Sports

Recreational city parks came into being to alleviate the pressures of urban living in an age of industry. Planned as beautiful landscape parks for the public, their main objective was to improve general living conditions with fresh air, stimulating design, and amenities like sports grounds, picnic areas, and pavilions for both entertainment and shelter.

Idylwild Park near Preston and the pavilion in Victoria Park in Kitchener make their attraction clear in these photographs. The solitary boatman, perhaps a poet, looks completely relaxed in the romantic, natural setting of the park; the pavilion, confidently exotic in design, was large enough for a variety of civic and cultural functions. Though neither facility lasted long, both thrived in the early years of the twentieth century.

Idylwild Park, on the banks of the Speed River between Preston and Hespeler, was accessible only on the G.P. & H. Railway.
Waterloo Historical Society

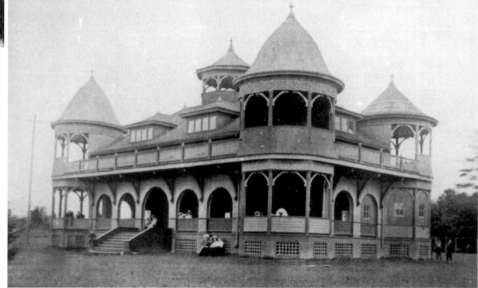

Victoria Park Pavilion, Kitchener.
The *Record* Historical Collection, University of Waterloo

Fountains in summer and outdoor ice rinks in winter: recreational opportunities for children appear wonderfully informal in earlier times. That the facilities might have been less than adequate by current standards was certainly not a matter of concern at the time.

Kuntz Park Fountain, on King Street at William, Waterloo, circa 1920.
Local History Department, Waterloo Public Library

Outdoor ice skating , Erb Street, Waterloo, 1959.
Kitchener-Waterloo *Record* Photographic Negative Collection, Dana Porter Library, University of Waterloo, Waterloo, Ontario N2L 3G1

Just as it did in the arts, participation in outdoor activities added valuable dimensions to county life. Here, members of a canoe club have come indoors and dressed for a studio portrait, and a CGIT (Canadian Girls in Training) group is examining the natural world at summer camp. Included in the groups are two artists whose perceptions of Waterloo County have profoundly enriched others' understanding of its landscape and peoples: painter Homer Watson and writer Edna Staebler.

Grand River Canoeing Club, 1880. Homer Watson is in the centre, at back.
Waterloo Historical Society

CGIT group at White Horse Camp, 1927. Edna Staebler, with a stick in her hand, is the nature study officer.
Edna Staebler Collection.

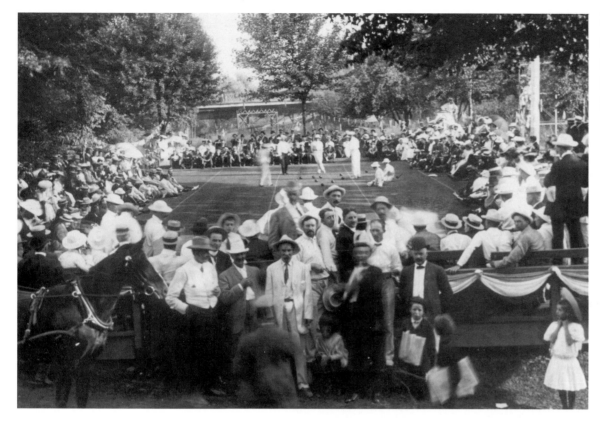

Lawn bowling, Waterloo. Waterloo and Stratford met in this final for the Labatt Trophy in 1906.
Local History Department, Waterloo Public Library

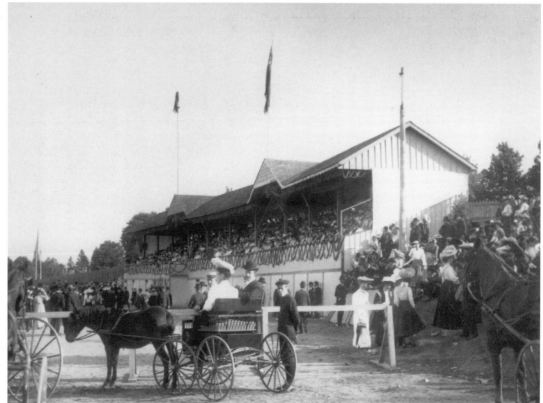

The Grandstand at the Galt Horse Show, Dickson Park, 1905.
James Esson/ National Archives of Canada/ C-025283

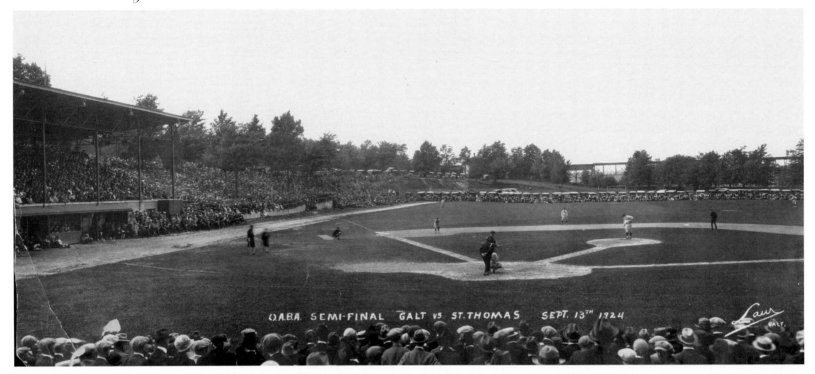

Ontario Baseball Association semi-final, September 13, 1924, Dickson Park, Galt. Thousands turned out for this thirteen-inning match between the Galt Terriers and St. Thomas. Galt won, but was defeated by the Toronto Royals in the final, also at Dickson Park. This photograph, composed of three separate exposures, qualifies as a heritage image: the remembered excitement of the game, the size of the crowd, and the details in the photograph itself continue to stimulate the imaginations of many Galtonians and county sports fans.
Elliot Law/Law Photography & the Cambridge Sports Hall of Fame.

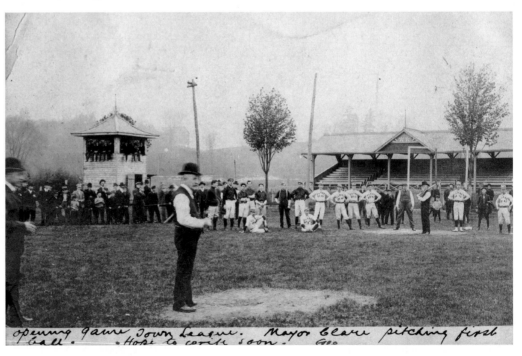

Mayor Fred Clare throws out the first ball at Riverside Park, Preston, circa 1906.
S.K. Walker Collection

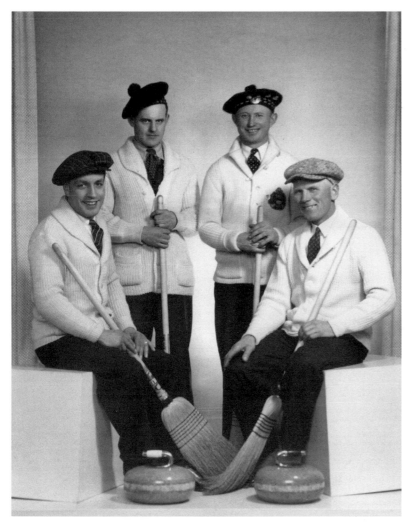

Curlers from the Galt Curling Club, circa 1950.
S.K. Walker Collection

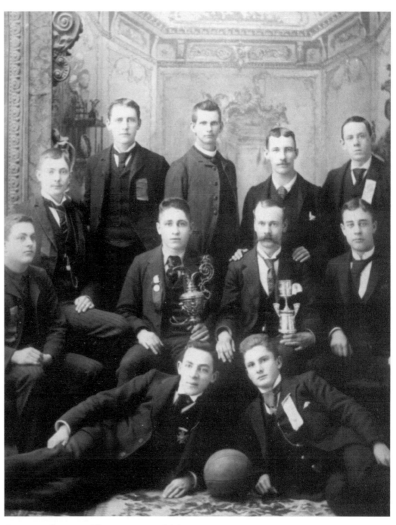

District Soccer Champions, 1890.
Tim C. Walker Collection

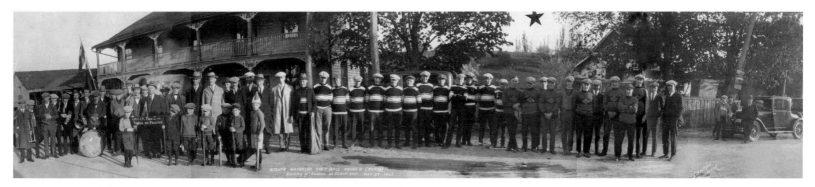

South Waterloo Soft Ball Association (rural). Opening game of the season, Blair, May 27, 1927. Both teams are present, along with the Oddfellows Musical Society band and two youths carrying a sign that reads "Under twin city rules we prosper."
Cambridge Sports Hall of Fame

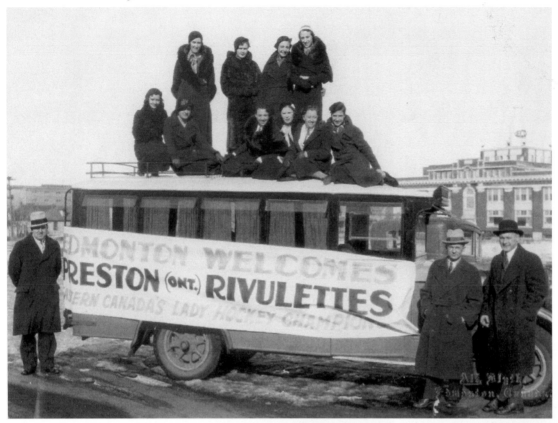

Preston Rivulettes, "eastern Canada's lady hockey champions, on tour." The Rivulettes, active in the 1930s, were a phenomenon unmatched in Canadian sports history; they won all but 5 of the 350 games they played during that decade, and three of those were ties. Cambridge Sports Hall of Fame.

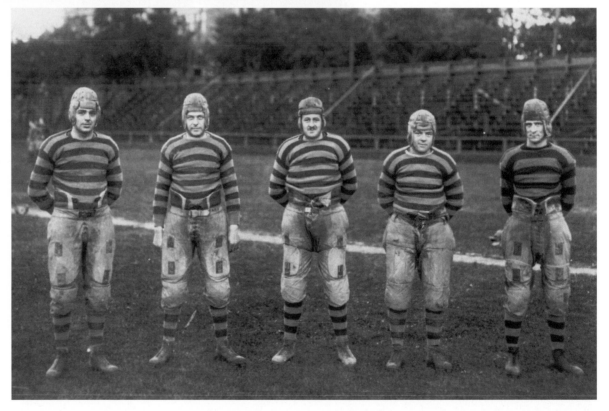

Kitchener Waterloo Rugby Club, Intermediate Dominion and O.R.F.U. Champions, 1927. Local History Department, Waterloo Public Library

18
Being Here

This category began with the Hummel brothers (or Hummell, or Humel): Thomas, Joseph, and Martin, aged from eighty to ninety-four years. They were Roman Catholic farmers, according to the 1871 census, and likely came to Canada from Alsace. The archival information with the photograph indicates they are sitting in a yard in Maryhill, or New Germany as it was formerly called, probably around 1905. Soon, I put the photograph of the children on the boardwalk in Ayr with the Hummels, and then, gradually, the other images. My working label for them was "style." Taken together, the photographs cover the years from 1885 through to the 1950s and effectively represent changing forms of dress and deportment.

But that would not do for the Hummels. While they have obviously dressed for the occasion, and shared a common taste, it is their demeanor, their presence itself, that is striking. Taking that notion back to the other images was, if not a revelation, certainly a delight. The camera tells us who was here, or what was happening, at a particular moment. In some cases we would like to know more; in other cases, as with the Hummels, although we have very little information, what we can see strengthens the past. They were here.

The Hummel brothers in New Germany (Maryhill), circa 1905.
Region of Waterloo, Doon Heritage Crossroads

A rural family in Wellesley Township, circa 1910.
Laura Heipel Wagner/Region of Waterloo, Doon Heritage Crossroads

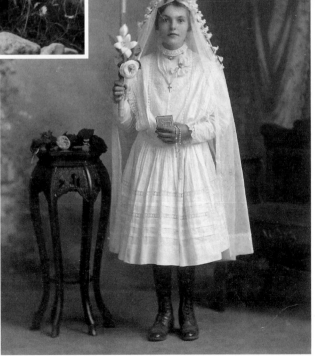

Children on Stanley Street, Ayr, before 1901.
Waterloo Historical Society

Esson portrait of a young girl, Preston, circa 1885.
S.K. Walker Collection

Communion portrait, possibly from New Germany (Maryhill).
Region of Waterloo, Doon Heritage Crossroads

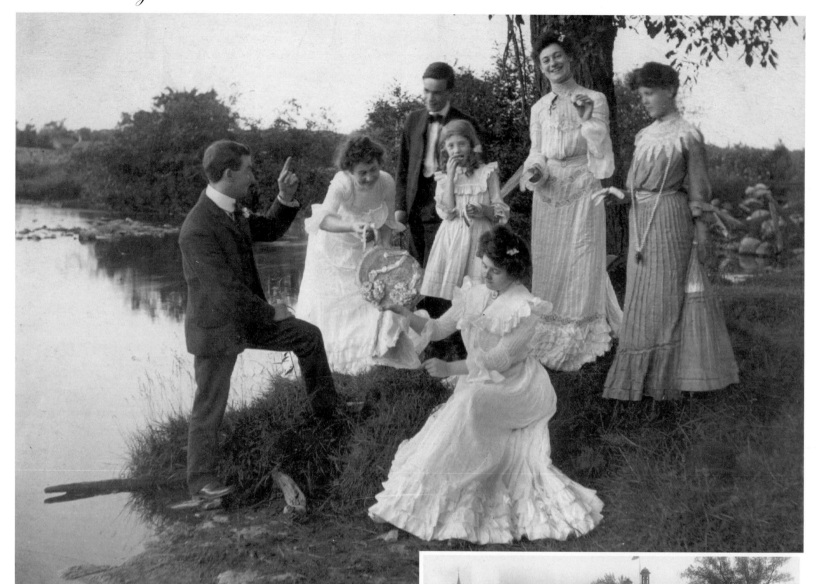

Picnicking, perhaps at Idylwild Park, Preston, circa 1905.
S.K. Walker Collection

School girls in Hespeler, on Kribs Street. The Public School, with its flag fluttering beside the bell tower, is behind the girls, down the street.
City of Cambridge Archives

Easter bonnets, Galt, 1933.
Norman Wildman/S. K. Walker Collection

Hiking to Paris in plus-fours, 1932.
Norman Wildman/S. K. Walker Collection

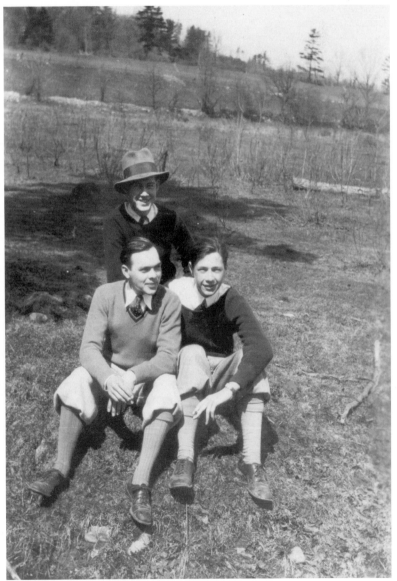

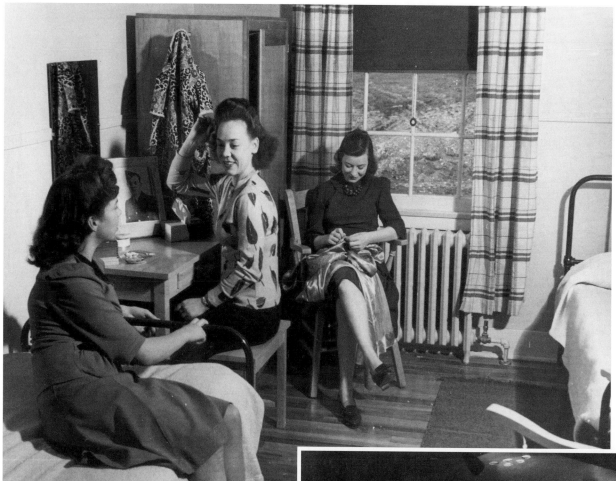

In the Dominion Woollens residence, Hespeler, during the war.
Waterloo Historical Society

John Kostigian's Orchestra brought the "big band" sound to Leisure Lodge in Preston from its opening in 1949 until 1981.
City of Cambridge Archives

"The last day in Waterloo County I made a circuit away around Conestoga, St. Jacobs, Wallenstein, Hawksville, St. Clements, Bamberg, St. Agatha and Petersberg to New Dundee and to Doon & the Red Lion Inn, but as I was coming south from Bamberg and looking east over the long rolling hills, by God! there it was, that great landscape where you could lose a whole bloody army corps; and I painted from a rise by the shadow of the bush beside the road. Bright fields, two wood lots, ploughing and a great blue green oat field in the foreground. Gods, did I work, lost track of time and light even and found it getting dark and I was cold and clammy with the day's heat and sweat. I never touched it again, only signed and dated at home."[xxvi]

— Carl Schaefer, quoted by George Johnston, August 1969.

John Martin, Carl Schaefer, and Jack Bechtel, on a Doon School of Fine Arts excursion to Ayr, 1952. All three painters taught at the school. For them, Waterloo County's landscape, rich in history and architecture, was a visual feast.

Kitchener-Waterloo *Record* Photographic Negative Collection, Dana Porter Library, University of Waterloo, Waterloo, Ontario N2L 3G1

A Moment of
Radical Change

The stones of the old Galt Hospital tumbled to the ground one day in December 1992, despite heroic and imaginative efforts to find a new use for the century-old building. In Jane Urquhart's novel *The Stone Carvers*, just such a moment of radical change brought one character "an increased awareness of the serendipitous quality of one's presence here on earth," causing her to wonder where any of us would be "had the slightest incident not occurred in the chaos of details that led to their birth. The past need do no more than shrug its shoulders or lift its eyebrows for us to cease to exist."[xxvii] That sensed fragility of existence has itself been radically changed by photography.

And yet, however much photographs may appear to capture the world as it is, they cannot always make the moment clear enough. In this image, a product of sophisticated technologies of speed, a powerful chunk of the past is caught as it disappears in one mighty shrug. This once imposing building was the repository of countless memories, many of them tied to the serendipity of being here. And now? What exactly is it that has ceased to exist? The memories remain. And so too do the photographs, including a 1902 image from a time beyond living memory.

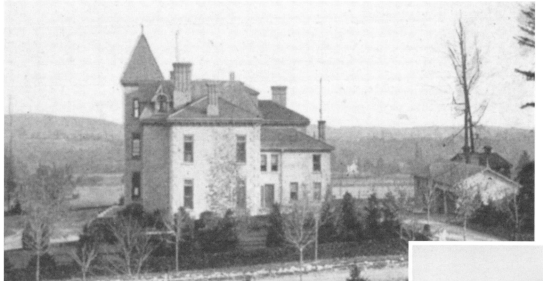

Eventide demolition, Galt, December 5, 1992.
Kitchener-Waterloo *Record* Photographic Negative Collection, Dana Porter Library, University of Waterloo, Waterloo, Ontario N2L 3G1

The Galt Hospital from Standpipe (the water tower), 1902.
Toronto Public Library

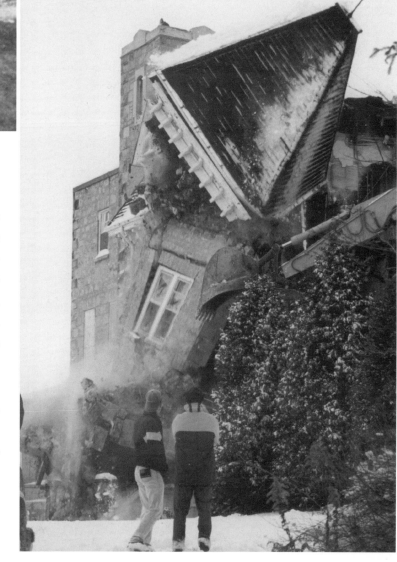

Whether or not the collapse of the hospital, or Eventide Home as it was known in 1992, was timely — a case of the building codes of one era clashing with the efficiencies of another — its disappearance from the landscape is a reminder of our habits. In *An Acre of Time*, a thoughtful chronicle of a small corner of Ottawa, Phil Jenkins claimed that cities — especially young ones like ours in Canada — "have always been cannibalistic. They eat large chunks of their own pasts, chewing up landscapes and buildings and regurgitating them. This municipal mastication implies a kind of hunger, the hunger to replace then with now, to recycle stale visions of a city with fresh ones."[xxviii]

Perhaps spreading photographs across a library table replaces that hunger with a taste for earlier visions. "Stale" is not on offer. Instead, at this feast there is change, mystery, travail, delight, wisdom, and more — more to think about, and more boxes of photographs still to be sorted.

Endnotes

i John Moss, *Invisible Among the Ruins: Field Notes of a Canadian in Ireland* (Dunvegan: Cormorant Books, 2000), p. 98.

ii Samuel Hughes, comp., *A Primer of Map Geography* (Toronto: W. J. Gage, 1883).

iii Shelley Rice, *Parisian Views* (Cambridge: MIT Press, 2000), p. 7.

iv *The Canadian Photographic Journal*, May 1892, quoted in Linda Brown-Kubisch, "150 Years of Photography in Cambridge," Waterloo Historical Society, *Annual Report* 80 (1992):131.

v Brown-Kubish, p. 135.

vi George Johnston, *Carl: Portrait of a Painter* (Moonbeam: Penumbra Press, 1986), p. 71

vii Susan Sontag, *On Photography* (New York: Farrar, Straus and Giroux, 1973), p.111.

viii Adam Ainslie, *On Life's Stage: The Autobiography of Adam Ainslie 1807–1896* (Cambridge: Corporation of the City of Cambridge Archives, 1987), p. 80.

ix J. B. Jackson, *The Necessity for Ruins and Other Topics* (Amherst: University of Massachusetts Press, 1980), p.102.

x Photo. *Crossroads in Time: A pictorial history of Tavistock (1890–1920) The Lemp Studio Collection.*

xi James Young, *Reminiscences of the Early History of Galt and the Settlement of Dumfries in the Province of Ontario* (Toronto: Hunter, Rose and Company, 1880), p.121-122.

xii Frank H. Epp, *Mennonites in Canada, 1786–1920: The History of a Separate People* (Toronto: Macmillan of Canada, 1974), p. 273.

xiii Rebecca Solnit, *A Book of Migrations: Some Passages in Ireland* (New York: Verso, 1998), p. 66.

xiv Nancy-Lou Patterson, *The Language of Paradise: Folk Art from Mennonite and other Anabaptist Communities of Ontario* (London: London Regional Art Gallery, 1985), p. 10.

xv John Mills, *Traction on the Grand: The Story of Electric Railways along Ontario's Grand River Valley* (Montreal: Railfare Enterprises, 1977), p. 5.

xvi Edna Staebler, *Sauerkraut and Enterprise* (rev. ed., Kitchener: Friends of Joseph Schneider Haus, 1993), p. 44.

xvii Mary Ann Kirkwood Van Sickle, "Pautlers & Hennings," in *Kirkwoods: A Genealogical Study* (Pittsburgh PA,1995), p. 17.

xviii M. W. Kirkwood, comp., *Historical Record: Canadian Pacific Electric Lines, comprising the Grand River Railway Company and the Lake Erie and Northern Railway Company* (Preston, 1939).

xix Karl Kessler, *Path of a People: Erb Street Mennonite Church, 1851-2001* (Waterloo: Erb Street Mennonite Church, 2001), p. 116.

xx George Roth and William Clack, *Canadian Pacific's Electric Lines (Grand River Railway Company and the Lake Erie & Northern Railway)* (Calgary: B. R. N. M. A., 1987), p. 7.

xxi Susan Saunders Bellingham, ed., "Selections from the Diaries of Louis Jacob Breithaupt," Waterloo Historical Society, *Annual Report* 76(1988):47.

xxii Rice, p. 7.

xxiii Barbara J. Stewart, Phyllis Leleu Kitchen and Debbie Dietrich, eds., *The Maple Leaf Journal: A Settlement History of Wellesley Township* (Linwood: The Corporation of the Township of Wellesley, 1983), p. 9.

xxiv Pierre Elliott Trudeau, "An Essential Grace," *Cultural Affairs* 6 (1969):5.

xxv Bernard Ostry, *The Cultural Connection: An Essay on Culture and Government Policy in Canada* (Toronto: McClelland and Stewart, 1978), p. 34.

xxvi Johnston, p. 99.

xxvii Jane Urquhart, *The Stone Carvers* (Toronto: McClelland & Stewart, 2001), p. 8.

xxviii Phil Jenkins, *An Acre of Time* (Toronto: Macfarlane Walter & Ross, 1996), p. 179.

Selected Readings

On Waterloo County

Bloomfield, Elizabeth, et al. *Waterloo County to 1972: An Annotated Bibliography of Regional History*. Kitchener: Waterloo Regional Heritage Foundation, 1993.

Bloomfield, Elizabeth. *Waterloo Township Through Two Centuries*. Kitchener: Waterloo Historical Society, 1995.

Burke, Susan M. and Matthew H. Hill. *From Pennsylvania to Waterloo: Pennsylvania-German Folk Culture in Transition*. Kitchener: Friends of Joseph Schneider Haus, 1991.

English, John and Kenneth McLaughlin. *Kitchener: An Illustrated History*. Scarborough: Robin Brass Studio, 1996.

Hayes, Geoffrey. *Waterloo County: An Illustrated History*. Kitchener: Waterloo Historical Society, 1997.

McLaughlin, Kenneth. *Cambridge: The Making of a Canadian City*. Burlington: Windsor Publications, 1987.

McLaughlin, Kenneth. *Waterloo: An Illustrated History*. Windsor Publications (Canada), 1990.

McLaughlin, Kenneth, et al. *Hespeler: Portrait of an Ontario Town*. Hespeler: Company of Neighbours, 2000.

Quantrell, Jim. *A Part of Our Past: Essays on Cambridge's History*. Cambridge: City of Cambridge Archives, 2000.

On Landscape and Photographs

Jackson, J. B. *The Necessity for Ruins and Other Topics*. Amherst: University of Massachusetts Press, 1980.

Price, Mary. *The Photograph: A Strange Confined Space*. Stanford:

Stanford University Press, 1994.

Riley, Robert B. "The Visible, the Visual, and the Vicarious: Questions about Vision, Landscape, and Experience," in Paul Groth and Todd W. Bressi, eds. *Understanding Ordinary Landscapes*. New Haven: Yale University Press, 1997.

Shepheard, Paul. *The Cultivated Wilderness, or, What is Landscape?* Cambridge: MIT Press, 1997.

Sontag, Susan. *On Photography*. New York: Farrar, Straus and Giroux, 1973.

Acknowledgements

Although old photographs can bring the past forward in an instant, finding pertinent images required the co-operation of archivists and collectors. For their patience and expertise, my thanks to Liz Hardin at Doon Heritage Crossroads; Susan Hoffman in the Kitchener Public Library's Grace Schmidt Room; Janet Sealy in the Local History Department of the Waterloo Public Library; Dianne Seager in Special Collections at the University of Waterloo; Linda Hubert Hecht and Sam Steiner of the Mennonite Archives of Ontario, Conrad Grebel University College; Marilyn Sararus, Heritage Wilmot; Jim Quantrell, City of Cambridge Archives; Cam Allan, Cambridge Sports Hall of Fame; and W. J. Gladding for the Lemp Collection. For making large collections manageable, my thanks go to Sandy Arbuthnot at the Toronto Public Library and to the staff at the National Archives of

Canada. For guiding me through their own remarkable photographs, I am grateful to David L. Hunsberger and Harold Kinzie, and to Peter Ross for access to Elliot Law's photographs. For assistance with particular images, thanks go to Frances Dewdney, John Clare, and George Roth.

The distinctiveness of Waterloo County has been made richer for me, over many years, through conversations with John Martin in my youth and later ones with Nancy-Lou Patterson and Edna Staebler; their expressed delight in the county is a tremendous resource. I am also grateful to Susan Burke at the Joseph Schneider Haus for her very helpful advice and to Clara Rutsch for sharing her memories of Waterloo and her extensive newspaper collection.

Within my family, several specific acknowledgements are due. First my thanks to my sisters: Mary Ann Van Sickle made a direct

contribution to my understanding of Waterloo County by gathering together genealogical threads and weaving them into the history of southwestern Ontario; Patricia Weber, whose delight in monitoring change parallels my own, has helped me mix memory and new information. My gratitude extends to the next generation: to Tim Walker, for his wise counsel on the geography of the county and his awareness of moments in its sporting life; and to Julian Walker, whose marvelous imagination and encouragement brought the project to life. Thanks also to my husband, Jim, for his keen critic's eye.

Even with all of this assistance, there would still be no book were it not for the enthusiastic support of Tony Hawke and the efforts of the staff at Hounslow Press and the Dundurn Group. Jennifer Scott's sense of order and Andrea Pruss's understanding of the comma were gifts.